IMAGES
of America

BOOMTIME BOCA
Boca Raton in the 1920s

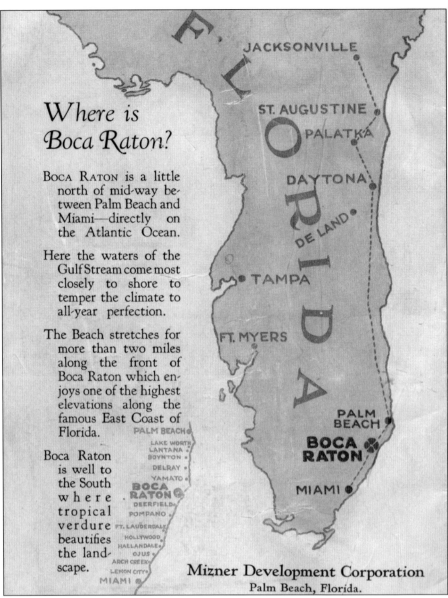

Where is Boca Raton?

Boca Raton is a little north of mid-way between Palm Beach and Miami—directly on the Atlantic Ocean.

Here the waters of the Gulf Stream come most closely to shore to temper the climate to all-year perfection.

The Beach stretches for more than two miles along the front of Boca Raton which enjoys one of the highest elevations along the famous East Coast of Florida.

Boca Raton is well to the South where tropical verdure beautifies the landscape.

Mizner Development Corporation
Palm Beach, Florida.

The name of the small farming village of Boca Raton, Florida, became an overnight national buzzword when Palm Beach architect Addison Mizner initiated the Mizner Development Corporation at the height of the Florida land boom in 1925. Mizner did not invent Boca Raton—but there is no question he put it on the map. The town boasted a couple of hundred residents at the time. (Boca Raton Historical Society [BRHS].)

ON THE COVER: Guests enjoy the view from the "cloister" at the Cloister Inn, Addison Mizner's beautiful Spanish-style hostelry built overlooking Lake Boca Raton. Mizner hurriedly completed the hotel to accommodate prospective investors in the Mizner Development Corporation's massive "Boca Raton" development project. The Cloister Inn opened in February 1926 to much critical acclaim. Today it still stands as a part of Boca Raton's own "palace," the Boca Raton Resort and Club. (BRHS.)

IMAGES
of America

BOOMTIME BOCA
Boca Raton in the 1920s

Susan Gillis and
the Boca Raton Historical Society

ARCADIA
PUBLISHING

Published by Arcadia Publishing
Charleston SC, Chicago IL, Portsmouth NH, San Francisco CA

Printed in the United States of America

Library of Congress Catalog Card Number: 2007920922

For all general information contact Arcadia Publishing at:
Telephone 843-853-2070
Fax 843-853-0044
E-mail sales@arcadiapublishing.com
For customer service and orders:
Toll-Free 1-888-313-2665

Visit us on the Internet at www.arcadiapublishing.com

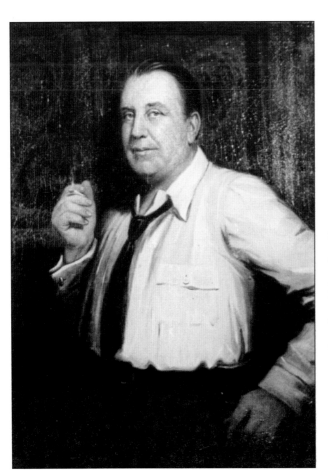

Architect Addison Mizner has been the object of various myths and legends since his death in 1933. Born in California, Mizner apprenticed in the San Francisco office of Willis Polk. After successful years in Long Island, he created the Everglades Club for sewing machine heir Paris Singer on the resort island of Palm Beach. Although Mizner did not invent the Mediterranean style that became so popular in Florida during the era, he was the unquestioned master and quickly became the darling of Palm Beach society. (BRHS.)

CONTENTS

ACKNOWLEDGMENTS

The Boca Raton Historical Society was founded in 1972 to collect, preserve, and disseminate information and artifacts relating to the past and evolving history of Boca Raton. Since that time, it has amassed an amazing collection of resources that documents the growth of what was once a small farming village to one of Florida's premier residential and commercial addresses.

Among the collections of the BRHS are 15,000 photographs that are pivotal in revealing the colorful history of a colorful community. These images have been acquired almost entirely through donation from generations of pioneers, former visitors, veterans once stationed here, and the local newspaper. This book would not have been possible without their contributions. In addition, the BRHS is grateful for its longtime relationship with the Boca Raton Resort and Club—formerly the Cloister Inn and later the Boca Raton Club—which has over the years donated many of the awe-inspiring images and scrapbooks about the hotel and the Mizner Development Corporation.

The historical society is also fortunate to be associated with a long record of truly professional historical scholarship. Dr. Donald Curl, professor emeritus at nearby Florida Atlantic University, has had a decades-long association with the BRHS. Curl is the coauthor of the city's principle history reference, *Boca Raton: A Pictorial History*, and editor of the BRHS scholarly journal *The Spanish River Papers*. The nationally known architectural historian's 1984 book *Mizner's Florida: American Resort Architecture* corrected many of the mythologies about the architect and his work and helped bring this amazing artist, and the city of Boca Raton, to national attention once again. His research, publications, and advice have been pivotal in this work. Equally important to this book is the dogged research and unceasing interest of longtime BRHS archivist Peg McCall, the author's predecessor. This book would not have been possible without her organizational skill, historical sleuthing, and curatorship of the historical society's collections.

Lastly I must thank the many volunteers to the historical society who over the years have assisted in the research and organization of the collections. Their work has likewise been vital to this publication.

INTRODUCTION

Boca Raton, located in Palm Beach County, Florida, received its name largely by accident. Literally "mouse mouth," the original Boca de Ratones appears on 18th-century maps on Biscayne Bay to the south, in the area now known as Miami Beach. The derivation of the name is now obscure; however, by the 19th century, mapmakers were identifying the current city's lake as Boca Ratone Sound. In the 1890s, Henry Flagler's Florida East Coast Railway was extended south from West Palm Beach to Miami, and a settlement grew up around the new community of Boca Ratone. By 1920, it boasted a bridge over the East Coast Canal, paved roads, electricity, a school, and phone service (four of them). It also boasted 100 residents.

The little farming community was ideally situated when the Florida real estate boom of the 1920s grew into a national phenomenon. Investors and new residents were drawn to the state from all over the country, a time Floridians have since known as "The Boom." In April 1925, well-known Palm Beach society architect Addison Mizner revealed his plans for an ambitious new development at Boca Raton. They included a gigantic oceanfront hotel, elegant mansions, golf and polo grounds, and palm-lined boulevards. Boca Raton was to be "the world's premier resort," "the dream city of the western world," "the world's new social capital." Town fathers were so impressed they actually engaged his services as city planner for the newly incorporated town.

Mizner quickly completed his sales office and Boca Raton headquarters, known as the Administration Buildings, and a small hotel on the western side of Lake Boca Raton to house potential investors. The Cloister Inn, constructed in his characteristic Mediterranean style, opened in 1926 to much acclaim. Other construction projects began throughout town. Meanwhile, popularity of Mizner's projects stimulated similar south county developments: George Harvey's Villa Rica featured property extending from Dixie Highway to the ocean in the northern part of town. A number of homes were actually constructed on what is now North Federal Highway.

The new town blossomed as well. Plans for a city hall were drawn up by Mizner; two versions proved too costly for the city's coffers, and the final design was completed by Delray architect William Alsmeyer in 1927. The city also established police and fire departments and purchased a shiny new fire engine, "Old Betsy." The population of the town grew to several hundred residents.

By the fall of 1926, however, the Boom was at an end. Negative press from Northern newspapers and an embargo on building supplies on what was then the only railway on Florida's east coast were exacerbated by the potential residents who came during Florida's summer season. The latter found no place to stay, bugs aplenty, and high heat and humidity. To add insult to injury, on September 18 of that year, a category four hurricane struck South Florida, causing pervasive damage, death, and injury. New residents left in droves. The Boom was bust.

In the fall of 1927, original Mizner Development Corporation investor Clarence Geist acquired the company's holdings for a mere $72,000. Geist immediately laid plans for the expansion of the Cloister Inn, hiring famed New York architects Schultze and Weaver to more than double the size of the original hostelry. The new Boca Raton Club opened to guests in December 1929. Geist's hotel was in many ways the financial savior of the young town, providing employment for both

the black and white community in very hard times indeed. Boca Raton also benefited from the many amenities Geist brought to serve his hotel patrons: a new railroad station and one of the most modern water treatment plants in the state at the time.

Boca Raton returned, for the most part, to its small-town agricultural heritage by 1930. With the outstanding exceptions of the Boca Raton Club and other boom-era construction, there were few signs of the glamorous resort community once envisioned by the great Addison Mizner. In 1930, the town's population was only 320 full-time residents. Today most of Mizner's dreams have long been realized, as Boca Raton has developed into not only a resort community but one of Florida's most prestigious addresses, home to 200,000 residents. We think he would approve.

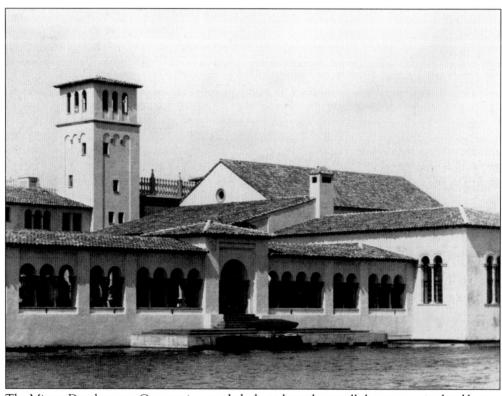

The Mizner Development Corporation needed a hostelry to house all the prospective land buyers coming to the area in 1925. Mizner quickly built the Cloister Inn, a small but elegant hotel on the western shores of Lake Boca Raton, which opened in 1926. Today it is the Boca Raton Resort and Club. This scene shows the yacht landing and "cloister" of the Cloister Inn. (BRHS.)

One

JUST PLAIN FOLKS

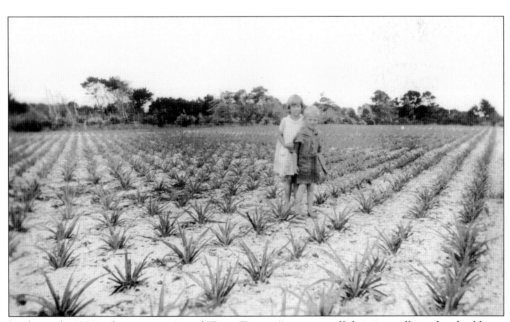

In the early 1920s, the community of "Boca Ratone" was a small farming village that had been founded adjacent the Florida East Coast Railway tracks and the East Coast Canal—today's Intracoastal Waterway. Boca was well known for her pineapple crop, or "pines," in the early 20th century. Imogene and Buddy Gates pose on Frank Chesebro's pineapple lands south of today's Camino Real c. 1923. (BRHS.)

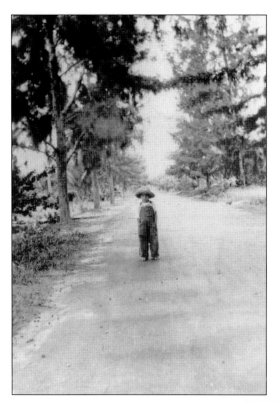

A very young Carl Douglas poses on Palmetto Park Road, today the city's north-south dividing line, c. 1922. Carl was the son of Lucas Douglas, bridge tender at the Palmetto Park Road bridge over the Intracoastal Waterway. Lucas's wife, Dessie, died of a heart attack in 1923, leaving him to raise his young children, Carl and Grace, at the bridge tender's cottage on the southeast side of the canal alone. (BRHS.)

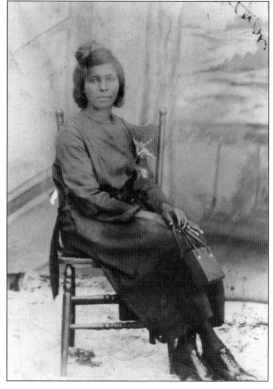

Boca Raton's early African American community consisted of farm laborers from Deerfield and Delray. Pearl City was a neighborhood specifically platted for black landowners on the Dixie Highway north of town in 1915. Today it is one of the city's designated historic districts, located between Northeast Tenth Street on the south and Glades Road on the north and between Federal and Dixie Highways on the east and west. The woman in this studio portrait taken c. 1919–1920 is only identified as an early resident of the community; pioneers no longer know her name. (BRHS.)

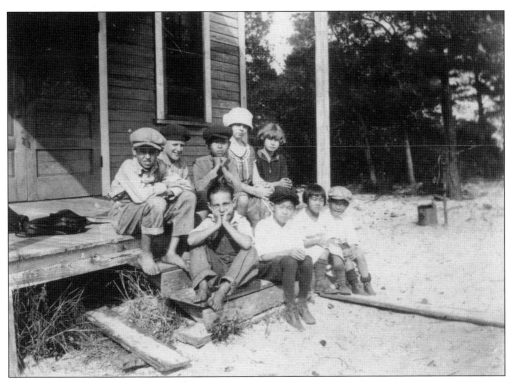

In the early 20th century, intrepid Japanese pioneers founded the farming community of Yamato in an area that is now north Boca Raton. The Yamato colony boasted a school, shown during the 1919–1920 school year. In attendance were the children of several white families who lived in the vicinity. From left to right are (first row) Andy Montgomery, Yamauchi Kazu, Masuko Kamiya, and Kazuo Kamiya; (second row) Vernon Richardson, Walter Smith, Frank Kamiya, teacher Clementine Brown, and Hazel Smith. (BRHS.)

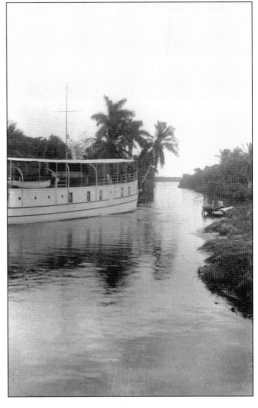

Florida's East Coast Canal, begun in the 1880s, provided an important transportation link for South Florida's early pioneers. The section through Boca Raton in the 1920s was largely pristine, with few homes and many scenic vistas. Here a houseboat moors just north of Lake Boca Raton c. 1919–1920. Today this is the Atlantic Intracoastal Waterway. (BRHS.)

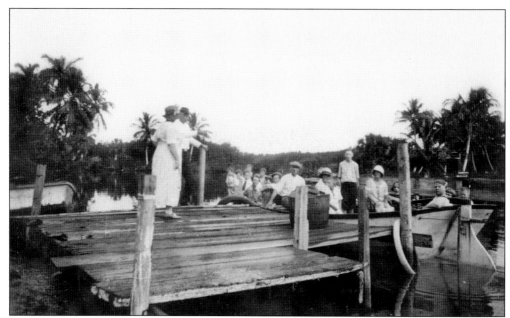

Most of the town's citizens board a vessel near the Palmetto Park Bridge over the Intracoastal for a community get-together, 1920s style. The original photograph is marked "going on a picnic at inlet" and "all Boca going on a fish fry"—a common gastronomic theme for the era. (BRHS.)

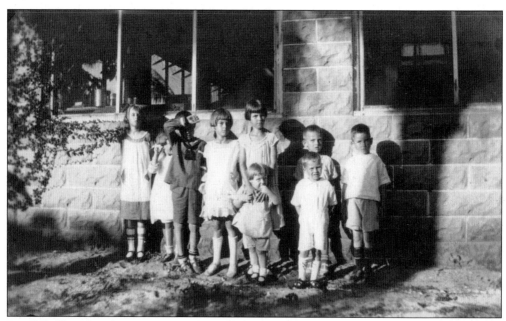

Local children found Boca Raton truly a tropical paradise in which to grow up. Here they gather for a party (you can tell by the fact everyone has on shoes) at the home of Harley and Harriette Gates c. 1921. From left to right are Dixie Sellers, two unidentified, Imogene Gates, Grace Douglas (with an unidentified toddler in front), Buddy Gates with Carl Douglas in front, and Paul Sellers. (BRHS.)

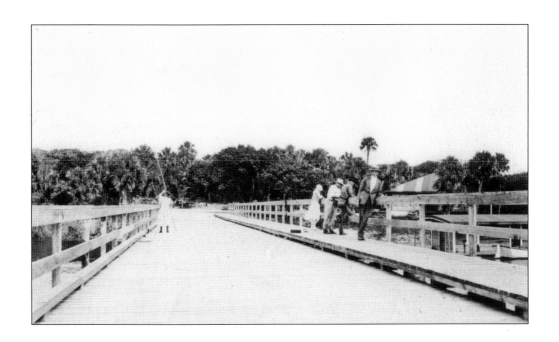

The first bridge constructed over Boca Raton's inlet was a fixed span completed in the early 1920s. It was pivotal to the completion of A1A, the new oceanfront highway through the area, and welcomed tourists and prospective land buyers to Boca Raton and South Florida. The original bridge had an east-west orientation; the view above is looking east towards a recreation spot called Boca Ratone by the Sea. The same bridge is shown below, looking from Boca Ratone by the Sea west and south of the inlet. Notice the extensive vegetation in the area, which was destroyed by the hurricanes of the late 1920s. (BRHS.)

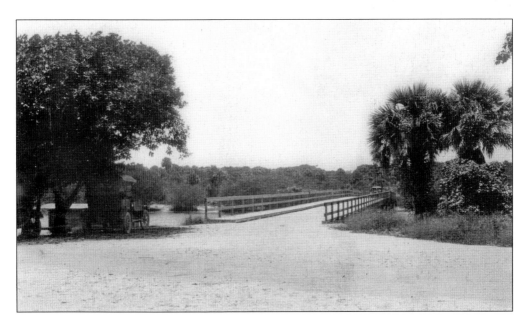

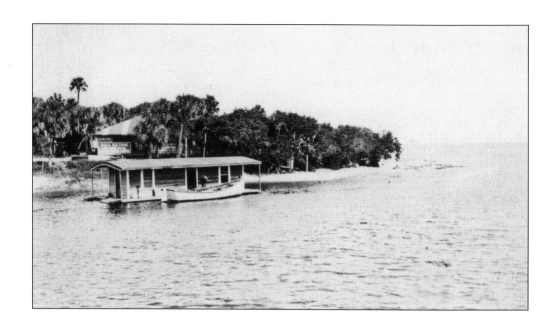

Boca Ratone by the Sea was a multi-function entertainment facility, or casino, located on the north side of the Boca Raton inlet. It featured a dance floor, docks, ocean fishing, a restaurant, and a beach, plus gas pumps and other travelers' needs in the early 1920s. The picture above shows a view of the site from Boca's frequently silted inlet. The image below features a close-up of the dance pavilion. Most of the buildings were destroyed by the storm surge during the record hurricane of September 1926. Today this is the site of the Boca Beach Club. (BRHS.)

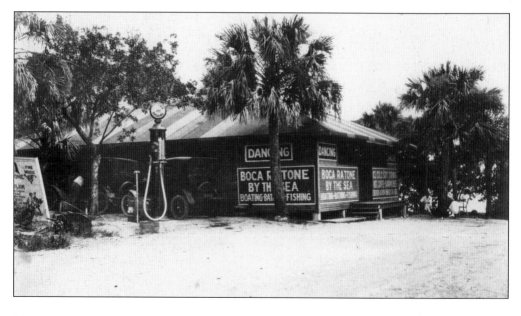

The casino was an important gathering place for local residents as well as tourists and a prime fishing spot. Above, vintage vehicles park in the limited shade at the site c. 1920. The view is looking south, and the bridge is just out of view at far right. Notice the Michelin tire advertisement at right. Below, Boca residents gather with their impressive catch in front of the dance pavilion, c. 1919–1920. During the 1910s, local residents spelled the town's name "Boca Ratone" to ensure its proper pronunciation, with a long "o." By the mid-1920s, the "e" had disappeared. (BRHS.)

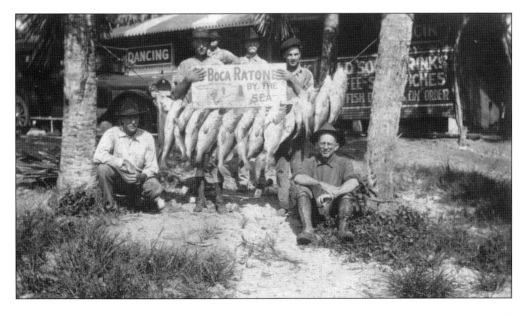

Harry Chesebro was the son of Boca pioneer Frank Chesebro, who settled in the new community of Boca c. 1903. Harry was an eyewitness to the phenomenal growth of the tiny "pineapple town." He met and married Ethyl P. Brown of Queensbury, New York, in October 1922. Despite her Yankee origins, Ethyl was quickly embraced by Harry's family and the townsfolk as a bona fide Bocan. (BRHS.)

Harry brought his bride back to this small wood-frame bungalow he built for her in 1924 at 360 South Dixie Highway. Their home was very comfortable with a luxuriously screened porch—protection against the local killer mosquitoes. It also featured a fireplace, necessary for the two or three cold days of the wintertime. Note the two-car garage at left as well. (BRHS.)

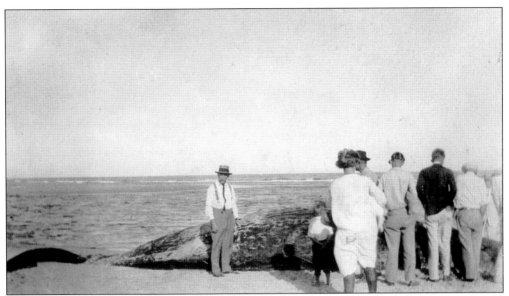

This image documents an unusual occurrence on local beaches when a whale washed ashore in December 1926. Townspeople gathered for a gawk; Grant Hollenbeck is shown facing the camera. Citizens reportedly harvested 13 barrels of oil from the creature. They also dynamited the carcass, causing an unlooked-for consequence—the smell permeated the area for weeks. (BRHS.)

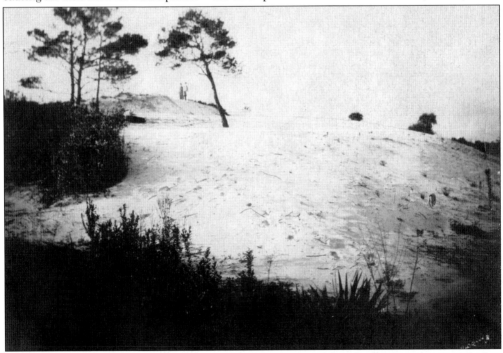

Boca pioneers were aware that Native Americans had trodden the land in the years before Columbus. This hill, now called the Barnhill Mound, is actually a burial mound for the prehistoric Tequesta Indians. The mound is not covered with snow, but rather Boca's famous "sugar sand." Two local explorers catch the view over one of the highest points in a sea-level city in the mid-1920s. (Photograph by A. H. Brooks; BRHS.)

Boca Raton's first school was a wood-frame structure that stood west of the Florida East Coast Railway tracks and north of Palmetto Park Road, near today's police headquarters. In 1920, this building was replaced with a new building located south of Palmetto Park and west of the tracks—the Boca Raton School. The 1920 building shown above is long gone, but the site is today the home of the current "Boca El"—Boca Raton Elementary. Below, students dressed in an interesting array of costumes crouch in the sand of the school grounds around the 1920s. They appear to be practicing for some elaborate pageant. A large American flag flies in the background at right. (BRHS.)

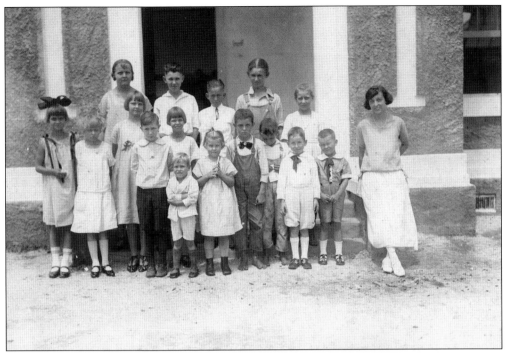

The new school was constructed in what was then the very popular mission style, a precursor to the more elaborate Mediterranean-style public buildings to come. Here a class photograph reveals the stuccoed detail of the school facade in 1924. From left to right are (first row) Pauline Raulerson, Dixie Sellers, Ivy Raulerson, Bertice Tanner, Grace Douglas, Carl Douglas, Grace Bowsman, Theron Dillingham, unidentified, Paul Sellers, Charles Raulerson Jr., and teacher Alice Presley; (second row) Myrtle Lee Raulerson, Odas Tanner, Clifford Purdom, Pearl Dillingham, and Elizabeth Dillingham. (BRHS.)

By 1926, the influx of new residents caused the addition of two schoolrooms (to a two-room school). Looking very flapper-like with their bobbed hair and short skirts are, from left to right, Bly Davis, teacher Alice Presley, and Pauline Raulerson, posing in front of the school in that year. (BRHS.)

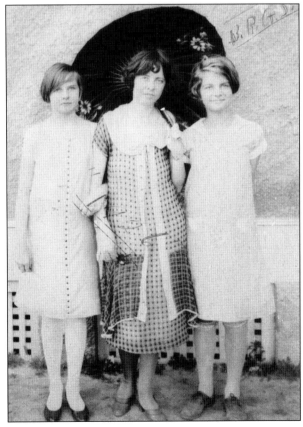

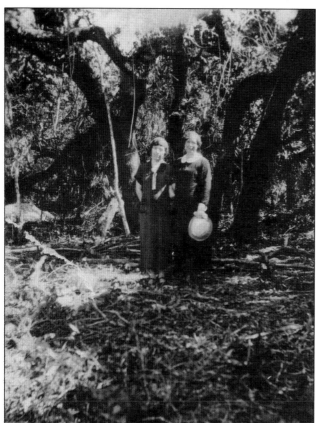

Por La Mar, one of Boca Raton's most glamorous subdivisions, lies just west of the ocean and east of the Intracoastal, just south of Palmetto Park Road. In the early 1920s, it was still wildly beautiful, with large sprawling live oaks—some of which still survive. Here pioneers Floy Mitchell (left) and Peg Young (right) pose at Por La Mar "park" sometime in the early 1920s. (BRHS.)

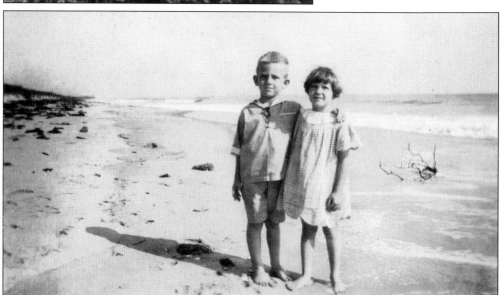

An obvious favorite attraction for local youngsters in the early days was Boca Raton's extensive beaches. They were, at the time, virtually free of development, and the birds and marine life were undamaged by modern pollution. Buddy Gates poses with friend Patsy Nelson on an amazingly pristine Boca beach in the mid-1920s. (BRHS.)

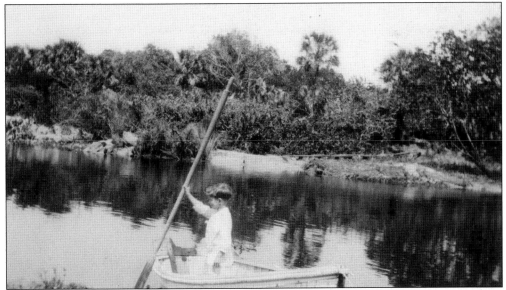

In addition to the beaches, Boca Raton was surrounded by many canals used by early residents. These included the Hillsboro Canal at the southern end of town, the dividing line between Palm Beach and Broward County and a direct link to Lake Okeechobee; the El Rio, the former Hillsborough River, running north from the Hillsboro Canal on the west side of town; and the East Coast Canal, today's Intracoastal. Locals enjoyed quiet boating and fishing expeditions along these waterways. Above, Buddy Gates shows off his poling skills in the waters near his home on the Intracoastal around the early 1920s. Below, a photograph by A. H. Brooks reveals the serenity and lack of development of the East Coast Canal just north of Lake Boca Raton *c.* 1926. Today these waterways are lined with fine homes and condominiums. (BRHS.)

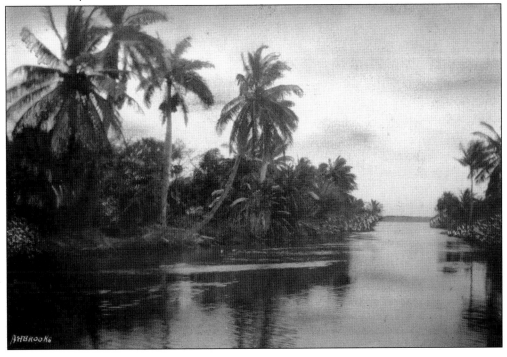

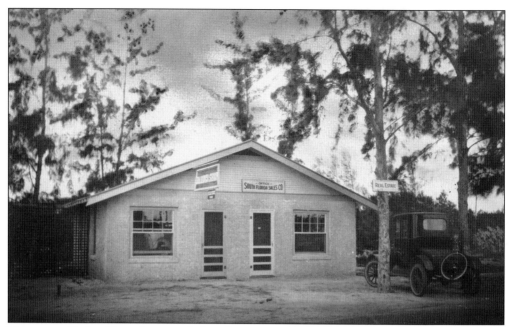

Vermonter Harley Gates first traveled to the area in 1907. In 1913, he returned to Boca Raton determined to stay. He soon built a home for his new bride and established experimental groves on his property on the East Coast Canal. Harley's genius was, however, for real estate. Harley built this modest office for the South Florida Sales Company, of which he was treasurer, on the Dixie Highway, *c.* 1923. (Photograph by A. H. Brooks; BRHS.)

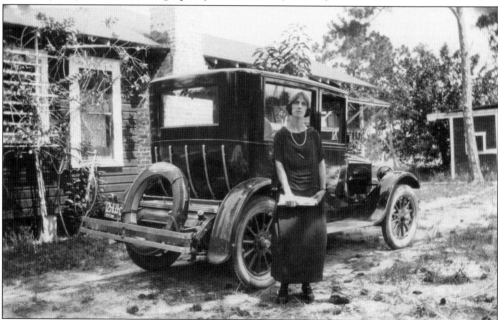

Harley's wife, Harriette, joined her husband in Florida in 1915. She suffered through the rusticity and isolation of the early community before enjoying the pleasures and "civilization" brought by the boom times. Here Harriette inspects one of the Gateses' rental properties located at 461 East Palmetto Park Road, *c.* 1923. (BRHS.)

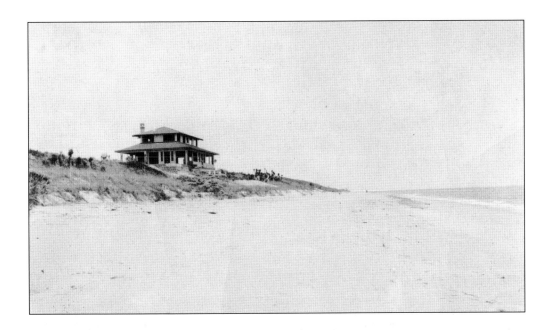

In the early 1920s, a man named Dr. E. Stanley Robbins constructed Boca's first beachfront mansion—a large, rambling, and window-clad house with prairie-style influences. The house sat on A1A not far south of Palmetto Park Road. In the 1930s, it was sold to Canadian publisher W. J. Southam. Later it served as Hermansen's and then the Ocean View Restaurant. It was demolished in 1964. Above, the house is under construction in the early 1920s, looking north. Below, a photograph by A. H. Brooks shows the completed house from the beach side, c. 1925. (BRHS.)

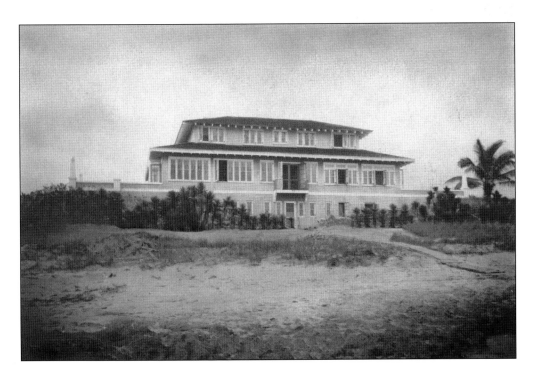

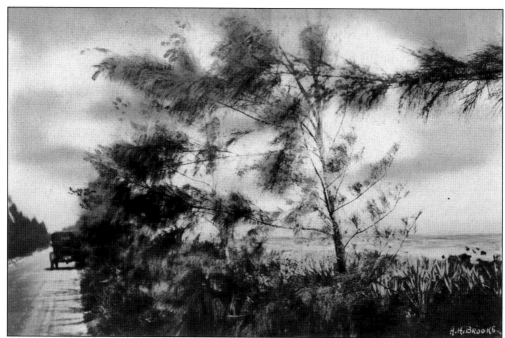

In the mid-1920s, the new ocean highway—A1A—was under construction on the southeast coast of Florida. This was an important lure to bring prospective investors and new residents to the area. These views by professional photographer A. H. Brooks reveal the lack of development along the beach area at the time. The image above shows the highway just north of Lake Boca Raton, the Atlantic Ocean and deserted beach visible at right. Below, the view looking south reveals the expansive and tree-lined waters of Lake Boca Raton to the right. The ocean is out of sight at left. Today this area is well populated with condominiums and expensive abodes. (BRHS.)

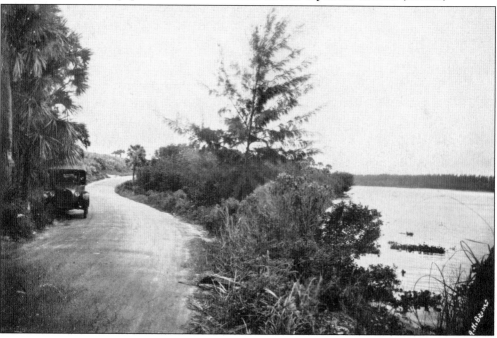

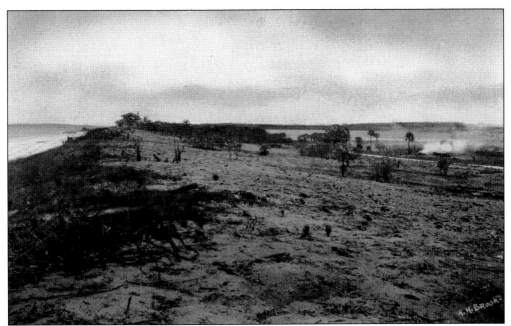

These two views by A. H. Brooks reveal Boca's pristine beachfront in the mid-1920s. Above and below are views of the Robbins House, the first beachfront mansion built in the early 1920s. Not surprisingly, the house was reputedly used as a refuge for contraband by the local bootleggers during Prohibition—undoubtedly true. Above, the view shows the beach looking south from about Palmetto Park Road. Notice the high bluff, which still exists at Boca's beach. At far right is Lake Boca Raton. The smoke is from a small fire. Below, the beach view is from south of the house looking north towards the Palmetto Park pavilion. (BRHS.)

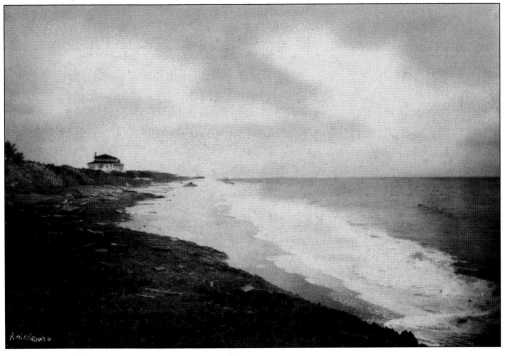

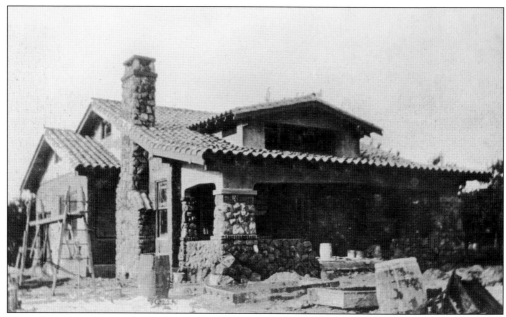

Theodore and Harriet Luff came to Boca Raton from East Orange, New Jersey, building this handsome bungalow at 390 East Palmetto Park Road in the early 1920s. The house, shown under construction above, was one of the town's finest examples of the classic bungalow style so popular in the early 20th century. Bungalows, also known as Craftsman style, featured gabled roofs and large porches with substantial supporting piers. They often employed local materials; the Luffs' house featured supports, foundation, and chimney of oolitic limestone—coral rock. Below, the Luffs welcome a friend to their new abode in the mid-1920s. (Photograph by A. H. Brooks; BRHS.)

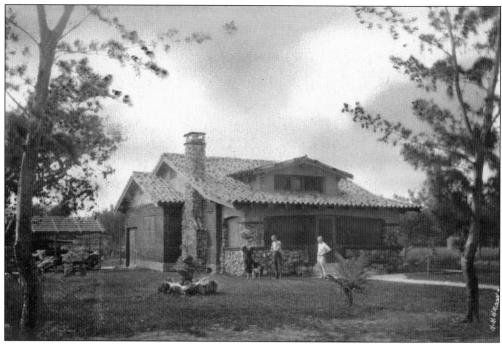

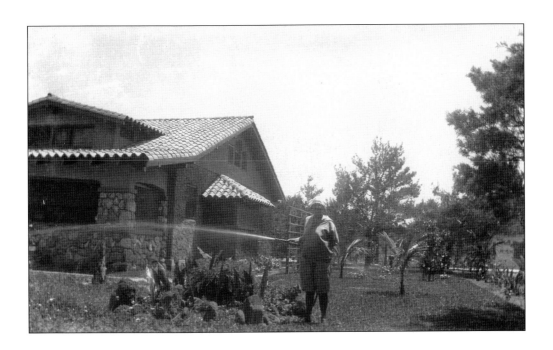

The Luff home stood on Boca Raton's central east-west highway: the road to the beach. In later years, it became a retail shop and was actually the first home of the Boca Raton Historical Society in the 1970s. Above, Harriet Luff performs a humble task, which we all recognize today but which would have been alien to the pioneer residents of the decade before—watering her lawn. The "swept yards" of sand and palmetto gave way in the 1920s to modern Florida landscaping. Below, Harriet and Theodore kid around with a fish head—possibly to be used as fertilizer—in the not-so-landscaped property adjacent their home around the mid-1920s. (BRHS.)

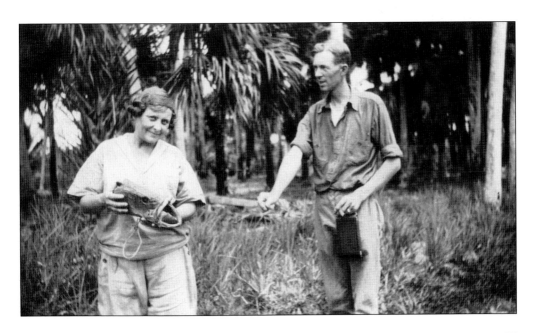

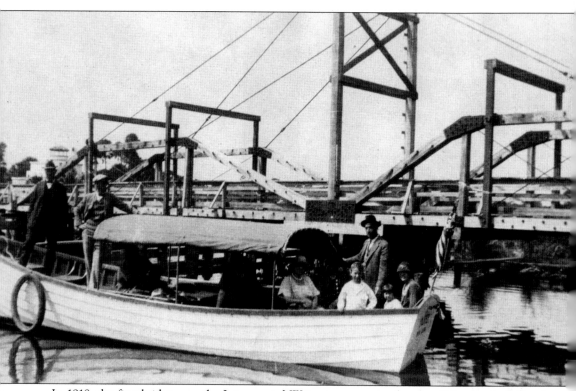

In 1918, the first bridge over the Intracoastal Waterway was completed at Palmetto Park Road, giving local vehicular access to the beach. This bridge was replaced in the late 1920s by a more modern, bascule type bridge. In this image, locals pose in Theodore and Harriet Luff's boat on the east side of the bridge in the mid-1920s. Grant Hollenbeck stands in the stern; Ann Wilcox sits by the flag, with Nancy Wilcox to her left. To their left stands Petie Moore in the white shirt. Perl Kinney is the gentleman in the dark suit in the bow. The tower of Casa Rosa, then the estate of Stanley Harris, can be seen in the background at left. (BRHS.)

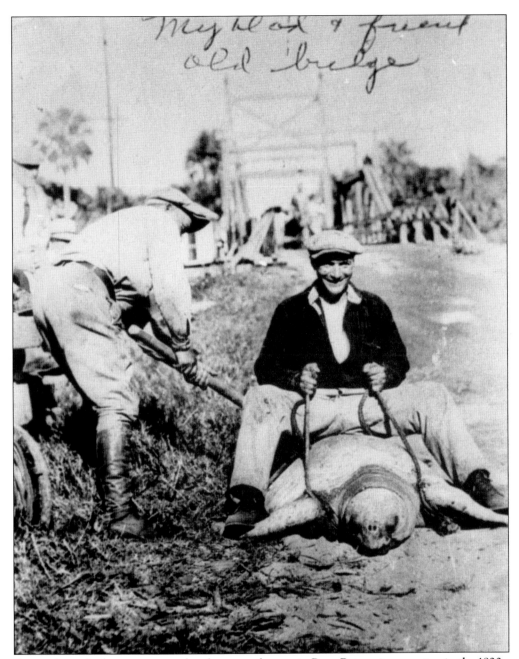

Sea turtles today have a respected and protected status in Boca Raton; it was not so in the 1920s. Boca's pioneers were accustomed to capturing and "turning" the large creatures to butcher them when they came ashore to lay their eggs. Pioneers also looked forward to the turtle egg harvests in the early days when chicken eggs were unavailable. In this *c.* 1927 photograph, Louis Zimmerman feigns a ride on a turtle's back hurried on by his friend Bill Deyo. The original Palmetto Park Road bridge is visible in the background; it featured an old-fashioned "swing"-style bridge, which was replaced by a drawbridge in 1928. (BRHS.)

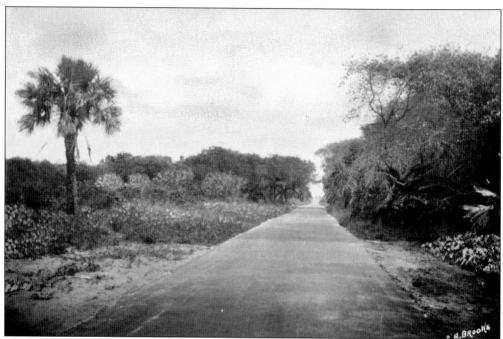

Palmetto Park Road east of the Intracoastal bridge was still a wild and undeveloped spot in the mid-1920s. The photograph above, taken by A. H. Brooks *c.* 1926, reveals the sabal palms, oaks, sea grapes, and other native vegetation only seen in the city's parks today. At the very center of the image, barely visible in an enlargement, is the city's first "ocean beach pavilion" at Palmetto Park Road. The first pavilion, shown below, was constructed *c.* 1926 at the foot of what was then Boca Raton's only beach causeway. The modest structure was the pride of the community, according to newspaper reports of the time. It was extensively damaged by the hurricane of September 1926 but was rebuilt soon afterwards. In 1930, it was replaced by a more elaborate structure designed by H. V. von Holst. (BRHS.)

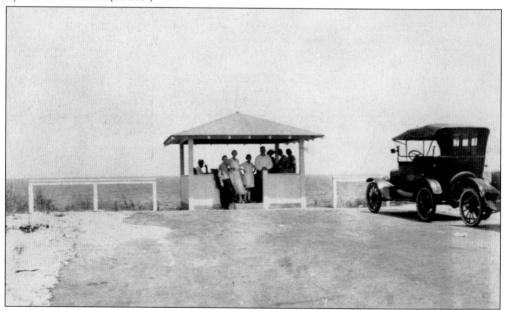

Two

THE MIZNER
DEVELOPMENT
CORPORATION

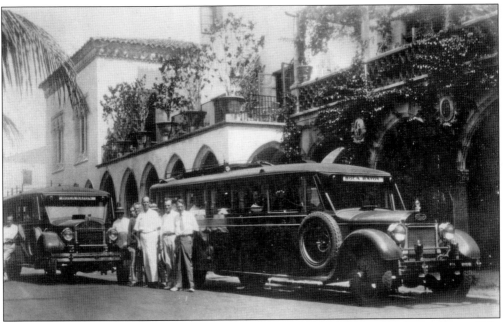

Mizner Development Corporation (MDC) buses destined for Boca Raton line up in front of Via Mizner on Worth Avenue, Palm Beach, c. 1925. The buses carried prospective buyers to view the amazing progress of architect Addison Mizner's plan for Florida's most talked-about boom-time development, Boca Raton. (BRHS.)

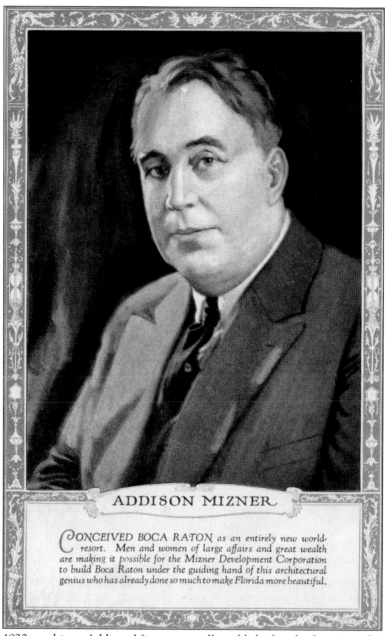

ADDISON MIZNER

Conceived Boca Raton as an entirely new world-resort. Men and women of large affairs and great wealth are making it possible for the Mizner Development Corporation to build Boca Raton under the guiding hand of this architectural genius who has already done so much to make Florida more beautiful.

By the mid-1920s, architect Addison Mizner was well established as the favorite architect of Palm Beach society, known for his elegant Spanish-style mansions, Via Mizner on Worth Avenue, and the exclusive Everglades Club. At the time, Florida was enjoying a land boom of legendary proportions. Mizner and his partners acquired two miles of oceanfront property and as much as 1,600 acres in the nearby small farming town of Boca Raton. His dream for the new development was to create "the world's most architecturally beautiful playground," a resort of landscaped avenues, golf courses, retail establishments, hotels, and fine homes. The newly incorporated town of Boca Raton actually appointed him as town planner. The Mizner Development Corporation immediately launched into a series of projects including hotel and street construction, infrastructure, and houses, funded in part by the over $2 million taken in on the first day of sales. (BRHS.)

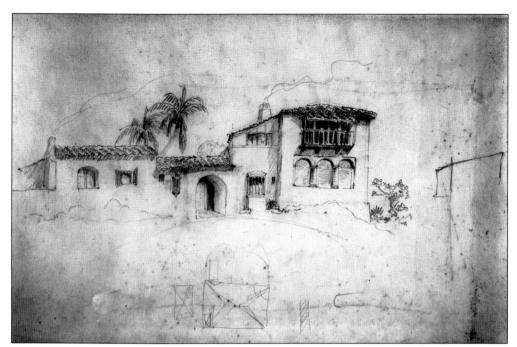

This sketch for a Mediterranean-style home from the mid-1920s is in the great architect's own hand. It is one of many from the Reynolds Clark collection at the Boca Raton Historical Society. (BRHS.)

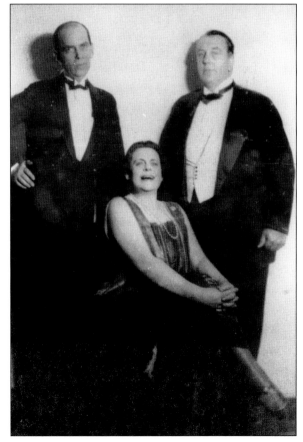

Addison Mizner, at right, is shown with partner and brother Wilson and actress and MDC supporter Marie Dressler. Wilson was a New York playwright well known for his wit and social connections. He was an officer of the Mizner Development Corporation with the assignment of bringing appropriate entertainment to Boca Raton. Dressler, the "Duchess of Boca Raton," was in need of a job when she came to help sell real estate for the corporation. (BRHS.)

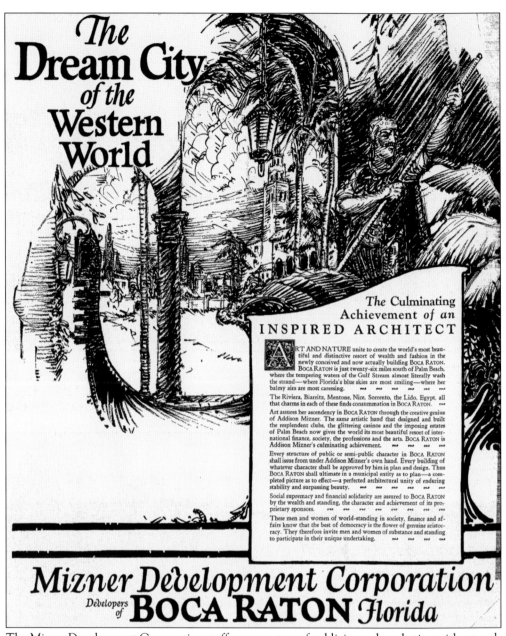

The Mizner Development Corporation staff were masters of publicity and marketing with a touch of hyperbole. A series of full-sized newspaper advertisements appeared not only in local papers such as the *Palm Beach Post* but the *New York Times* as well in 1925 and 1926. Here Boca Raton, then with a few hundred residents, is touted as the "Dream City of the Western World:" "The Riviera, Biarritz, Mentone, Nice, Sorrento, the Lido, Egypt, all that charms in each of these finds consummation in Boca Raton. Art assures her ascendancy in the creative genius of Addison Mizner. . . . Boca Raton is Addison Mizner's culminating achievement." (BRHS.)

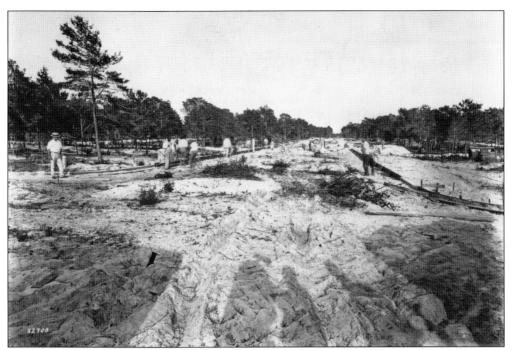

By the mid-1920s, the major route for automobiles through Boca Raton was the Dixie Highway, which followed the Florida East Coast Railway tracks through town. The Mizner Development Corporation began construction on a new major north-south thoroughfare called the King's Highway east of the Dixie. Today it is known as Federal Highway, U.S. 1. Here crews lay curbing for the King's Highway in 1925. (BRHS.)

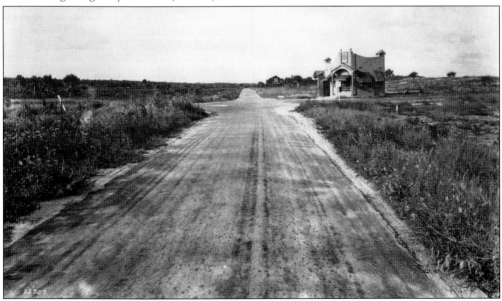

This view shows the active intersection of A1A (Ocean Boulevard) and Palmetto Park Road in 1925. The photograph is looking north, and the small building at right is the "beach office" for the Mizner Development Corporation. Just out of view to the right is the ocean and site of the Palmetto Park pavilion. (BRHS.)

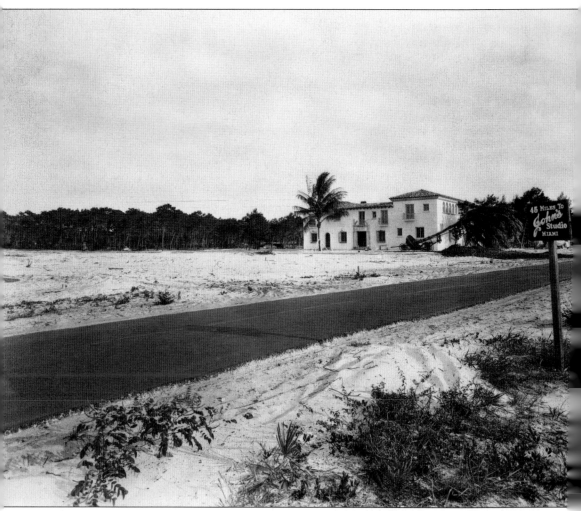

The Mizner Development Corporation required an administration building to house the salesmen, surveyors, and other project crewmembers for their extensive development projects. The Ad Building, as it is known, for Mizner's Boca Raton development is actually two structures: the North and South Administration Buildings on either side of a Spanish-style courtyard located at the corner of Dixie Highway and Camino Real. The North Administration Building, which faces Camino Real, was modeled on El Greco's house in Toledo, Spain. This image shows the landscaping underway at the Ad Building *c.* 1925, looking south on the Dixie Highway. Note the sign that advertises "45 miles to John's [photography] studio, Miami," on the otherwise deserted portion of highway. (BRHS.)

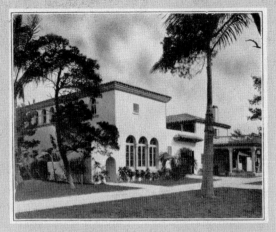

Administration

of all branches of the Mizner Development Corporation's activities is centered in this splendid building at the corner of the Dixie and Camino Real.

The Administration Buildings provided a central public focus for the burst of activity being conducted by the Mizner Development Corporation throughout town. The south facade of the north building, shown in a page from a MDC advertisement above, also reveals similarities to El Greco's Toledo garden, the inspiration for its design. In December 1925, MDC started serving lunch and tea on the porch and patio—Addison Mizner could occasionally be seen dining there. Below, Karl Riddle, chief engineer for the MDC, gathered his considerable crew of surveyors and engineers for a photograph in front of the Ad Building *c.* 1926. (BRHS.)

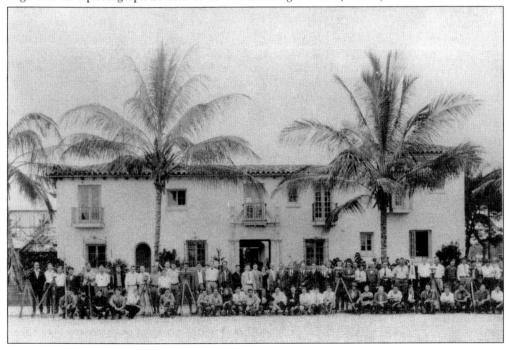

Camino Real

is one of the crowning glories of Boca Raton. It is wide enough east of the Dixie Highway to accommodate twenty-two lines of moving traffic.

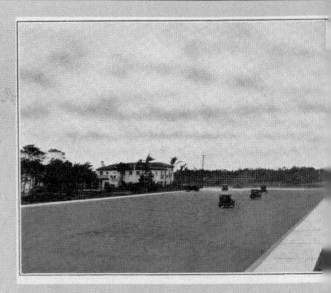

This image from a Mizner Development Corporation brochure features the Ad Building and the as-yet-undeveloped landscape west of Dixie Highway c. 1925. Camino Real, "the royal highway," shown looking west from Federal Highway, was Mizner's central boulevard for Boca Raton, planned so that residents could reach all parts of the resort within a few minutes by car. The eastern section, stretching from Dixie Highway to the beach, was optimistically broad to accommodate many lanes of traffic, as can be seen in the wide expanse shown here. Today this stretch of Camino Real features landscaping and a broad median. (BRHS.)

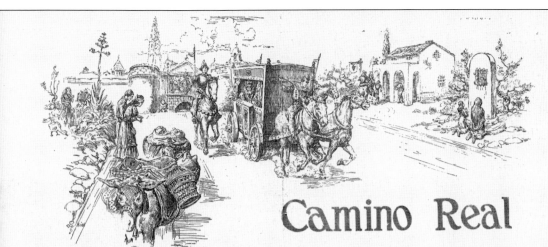

Camino Real
The Royal Highway of Boca Raton

STRETCHING east and west across the Mizner properties at Boca Raton—running from the magnificent Ritz-Carlton hotel and landing field to the western limits—will be the Camino Real or Royal Highway—a magnificent street of royal palms fit to serve as the principal highway of the finest resort of the world.

That will be Florida's street of streets—palm lined and 160 feet wide—almost three times as wide as a wide business street.

From the Camino Real, residents of Boca Raton will be able to reach all parts of the resort by automobile within a few minutes.

Other principal thoroughfares bordering Lake Boca Raton and OVER TWENTY MILES OF BROAD CANALS will be treated in masterly fashion to provide for Boca Raton a convenient system of streets, adequate for future needs and fit for the finest homes of America.

THE CAMINO REAL of Boca Raton will follow closely (as to general treatment) the magnificent system of state highways by which Spain first connected her principal cities. Running from Cordova to Seville and thence to Cordova and Toledo, were broad roads wide enough for the heavy traffic which flowed constantly between those places.

Along these roads marched the battered hordes of the East as Ferdinand and Isabella drove the Moors out of the country.

That was the beginning of modern Spain.

But before they went, the pioneers (Portuguese and Moors) left their marks upon Spain—a colorful jumble of character and custom which now makes Spanish architecture the most interesting in the world.

It is this wealth of historical significance which—Mr. Addison Mizner proposes—shall characterize the Camino Real of Boca Raton—a street of streets for the finest resort of the world.

Note: In early days, Junípero Serra, a Franciscan, established over thirty monasteries in California. These monasteries were located a day's walk apart and were connected by a broad highway.

Today, the Camino Real of California is a broad boulevard greatly favored by motorists who go to see the monasteries that Junípero Serra built.

Developers of
Boca Raton

The Resort of Unrivalled Opportunity

Mizner Development Corporation
Main Office: PALM BEACH, FLORIDA Phone 1101
Temporary Miami Office: Miami Beach: Temporary Tampa Office: Lake Worth:
Poinciana Leon Hotel 601 Collins Ave Fleiss 315 Hillsboro Hotel, Parlor A 100 Lake Avenue
OFFICE AT BOCA RATON

The inspiration for the Camino Real, according to the Mizner marketing machine, was the Camino Real of Spain, "the magnificent system of state highways by which Spain first connected her principal cities." The advertisement also refers to the "colorful jumble of character and custom which makes Spanish architecture the most interesting in the world" and which served as inspiration for much of the Boca Raton development. Also implied was California's El Camino Real, a 700-mile road that connected the Spanish missions in the 18th century. This fanciful two-page advertisement for the new Camino Real features an allusion to that mythical past, as a royal carriage makes its way through colorful Spanish-style countryside. (BRHS.)

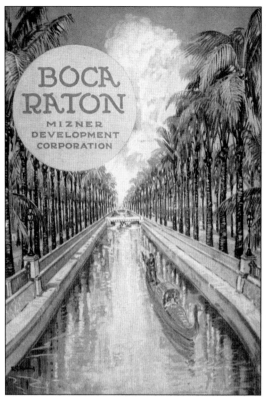

Camino Real was planned as a meandering boulevard extending west to the El Rio Canal then north, then west again past what is today the route of Amtrak and I-95. The area was then little more than swamp and scrubland. It is in this western section of the planned highway that "Venetian lagoons" were to be constructed, patterned after a beautiful boulevard in Rio de Janeiro. The lagoons would "contribute to the making of a fresh water fairyland," according to MDC marketing. A traffic avenue and wide landscaped walks on each side of the lagoons were to boast more than 7,000 royal palms along its course. At left, the cover of an MDC brochure reveals an artist's rendering of the proposed canal-centered Camino Real. Below, the original inspiration is shown in a Keystone View Company stereo slide view. (BRHS.)

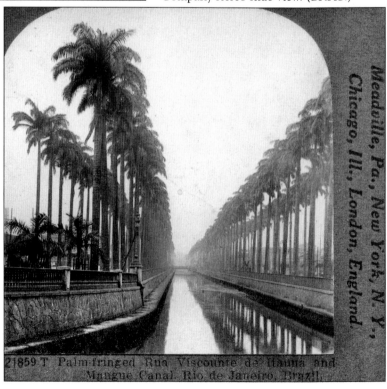

PLATTED AREA IN PERSPECTIVE OF THE
MIZNER DEVELOPMENT

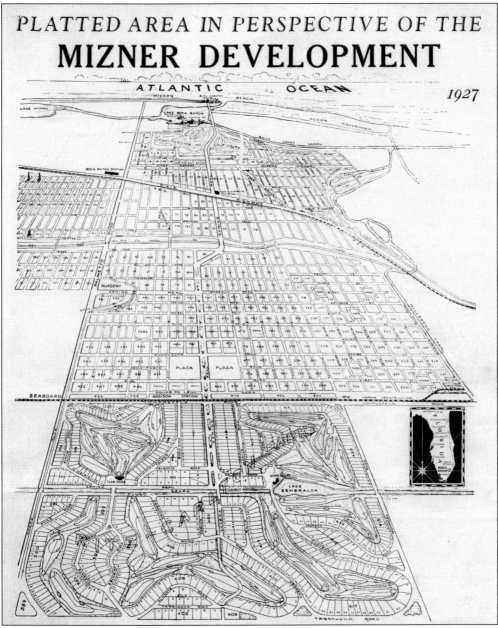

This map shows the various plats of the Mizner Development Corporation c. 1927, located primarily in what is today the southern part of the city. The street running to the ocean at left is Palmetto Park Road. At center, running from left to right, is the El Rio Canal, already completed in the 1920s. The central road, shown vertically, is Camino Real—notice the "lagoons" in the western portions of the boulevard. The curved roadway beyond the El Rio is the Dixie Highway—then the principle automobile route through South Florida. Lake Boca Raton lies in the far background, near the inlet. Notice the elaborate golf course communities of "Ritz Carlton Park" in the foreground, planned for what is now west of I-95. This is a concept we now associate with modern times. The western reaches of Mizner's planned project remained largely undeveloped until the completion of the interstate in the 1970s. (BRHS.)

41

I Am the Greatest Resort in the World

I Am Boca Raton, Fla.

◦A FEW YEARS HENCE◦

I HAVE the combined charms of dignity, beauty and numerous attractions designed for fastidious people.

⁂ ⁂ ⁂ ⁂ ⁂

I AM a place where people of taste can spend a few weeks, a season or the entire year in constant enjoyment.

⁂ ⁂ ⁂ ⁂ ⁂

I OFFER the most even tempered climate in the world. I honestly believe I am the coolest place in the tropics.

⁂ ⁂ ⁂ ⁂ ⁂

I CAN amuse people in many ways. I have as fine a bathing beach as can be found in the tropics. A magnificent Ritz-Carlton Hotel. A

handsome Inn. Beautiful homes. Grand plazas, wide boulevards and streets. Colorful business sections. Theaters showing Broadway plays. Marvelous cabarets. Tennis courts everywhere, golf links, a polo field and a great landing field for airplanes.

⁂ ⁂ ⁂ ⁂ ⁂

THIS is but a bare outline of what my future offers to the people who choose to live within my confines.

⁂ ⁂ ⁂ ⁂ ⁂

MY future must be glorious. I have Addison Mizner to make it so.

Mizner Development Corporation

PALM BEACH, FLORIDA **Developers of Boca Raton**

Miami Temporary Offices, Ponce De Leon Hotel, Miami, Florida

MIAMI BEACH TEMPORARY OFFICE, 424 COLLINS AVENUE — TELEPHONE 888

The MDC publicity department didn't hold back in this advertisement for the "greatest resort in the world . . . a few years hence." The advertisement claims: "I am a place where people of taste can spend a few weeks, a season or the entire year in constant enjoyment. . . . I can amuse people in many ways. I have as fine a bathing beach as can be found in the tropics. A magnificent Ritz Carlton Hotel. A handsome Inn. Beautiful homes. Grand plazas, wide boulevards and streets. Colorful business sections. Theaters showing broadway plays" and so on. What is not mentioned is that few of these projects were actually under construction; most were only on paper as yet. And the reason for this claim was patently obvious to the Mizner machine: "My future must be glorious. I have Addison Mizner to make it so." (BRHS.)

BOCA RATON

Where Promises Are as Good as the God-Given Soil

And here are the promises of the MIZNER DEVELOPMENT CORPORATION:

A NEW, MAGNIFICENT RITZ-CARLTON HOTEL OF 700 ROOMS
THE NEW, SPLENDID CLOISTER OF 100 ROOMS
THE CAMINO REAL—160 FEET WIDE—BISECTING THE DEVELOPMENT
LAKE AND CANALS DREDGED POLO FIELDS
THREE GOLF COURSES
AN ARTIFICIAL LAKE, ⅛ BY ⅜ OF A MILE IN SIZE
TENNIS COURTS

NO STREET will be less than sixty feet wide and many will be eighty feet wide. All streets will be paved for their full width and there will be private beaches restricted against all intrusion. ☜ ☜ ☜

ADDISON MIZNER — the man who is planning the city —is building at BOCA RATON a house to cost one million dollars and will live there himself. ☜ ☜ ☜ ☜

Every promise of the MIZNER DEVELOPMENT CORPORATION is made to be kept. Exaggeration has no place in BOCA RATON'S lexicon. The very names of the men associated with the development are an assurance of faith and the guaranty above, coming

from these men, is merely throwing of a spotlight onto the Sun. ☜ ☜ ☜ ☜ ☜ ☜ ☜

As FLORIDA grows — and it is expanding at a greater rate than has ever been noted before in the annals of migration — its fairest spot — its most endowed acreage

BOCA RATON

must grow—must thrive—at a faster rate than other less-favored spots. ☜ ☜ ☜ ☜ ☜ ☜ ☜

A glance ahead will assure you as no argument cap, that BOCA RATON is the magnet for the best — the most exacting — the most cynical element in the world. And—

READ *this advertisement. Analyze the promises. Note the guaranty above. Note the names of the men who make the guaranty. Then—ACT. Act while* BOCA RATON *is in the pre-development stage, for as sure as the new day comes* —new VALUES *come.*

Copyright, 1925

AN INVESTMENT TODAY IN BOCA RATON SOIL IS AN ANTICI-
PATION OF POTENTIAL PROFIT—OF RESIDENTIAL SECURITY

Mizner Development Corporation
Developers of BOCA RATON Florida

Anxious to forestall the negative publicity generated by many truly fraudulent boom-time "developments," the MDC lured investors with "promises as good as the God-given soil." Included in those promises were two hotels, the Camino Real, the dredging of Lake Boca Raton and adjacent canals, three golf courses, and other amenities. "Every promise of the Mizner Development Corporation is made to be kept." (BRHS.)

W YORK HERALD Tribune

SUNDAY, DECEMBER 27, 1925 SIXTEEN PAGES

..rough Florida With Open Eyes

By ROBERT B. PECK Illustration by W. FLETCHER WHITE

An Excerpt from The Story of Florida by Robert B. Peck

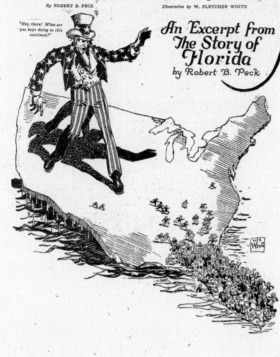

Boca Raton

Not much over six months old, has perhaps the most elaborate plans of any of the developments between West Palm Beach and Miami and is proceeding diligently toward their consummation.

Like most of the Florida coast line in this vicinity, the shore front of Boca Raton is not unlike the south shore formations on Long Island. There is a substantial bar or sandy peninsula on the ocean front, separated from the mainland by Lake Boca Raton. The inlet between the ocean and the lake, whose mouth Spanish voyagers thought resembled that of a rat, gives the name to the locality.

Already The Cloister, a million-dollar hotel on the shore of lake Boca Raton, is approaching completion and is making bookings for the present season. More than a hundred other buildings in this development are almost ready for occupation. Fourteen hundred men are at work clearing land leveling streets, excavating for sewers and water pipes, dredging a channel through Lake Boca Raton to the Cloister to permit seagoing yachts to moor at the very door of the hotel.

One of the boulevards of Baco Raton is to be 220 feet in width. The street is to describe a great circle, and in the center of it is to be a lagoon. Cement workers are molding curbing for the lagoon with a patented "pressure gun," process, it is said, which renders the cement 95 per cent waterproof and insures a seawall which will last for generations.

Of the 18,000 acres held by the development company, 3,000 are in actual process of development, with practically every lot sold, it is said. More than 70 per cent of the original purchasers already were residents of Florida. Receipts have been $28,000,000 and expenditures $14,000,000.

Cities spring up out of the wilderness with the speed of necromancy throughout Florida today. Boca Raton is merely an example.

Mizner Development Corporation

Developers of

Boca Raton

Administration Building Boca Raton

Main Offices:
Palm Beach, Florida
Phone 1195

George Fryhofer
General Sales Manager

Pullman ..en our .ch .ffices each morn- ept Sunday.

Administration Restaurant, Administration Building, Tenth and Dixie Highway, Boca Raton, Lunch, Tea, Dinner al fresco.

This advertisement features Uncle Sam asking, "Hey there! What are you boys doing to this continent?" as the entire population of the United States seemingly rushes to the Florida land boom. This 1925 excerpt from the *New York Herald Tribune* compares Boca Raton to Long Island and claims, "Not much over six months old [Boca Raton] has perhaps the most elaborate plans of any of the developments between West Palm Beach and Miami and is proceeding diligently towards their consummation." (BRHS.)

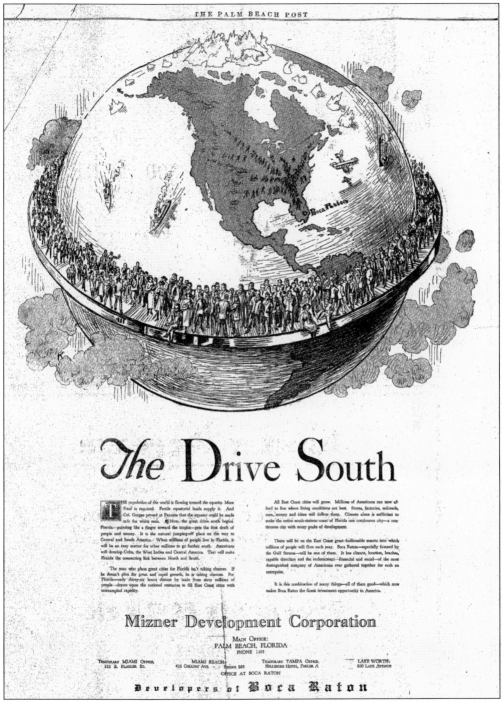

The Drive South

THE population of the world is flowing toward the equator. More food is required. Fertile equatorial lands supply it. And Col. Gorgas proved at Panama that the equator could be made safe for white men. ¶Now, the great drive south begins. Florida—pointing like a finger toward the tropics—gets the first draft of people and money. It is the natural jumping-off place on the way to Central and South America. When millions of people live in Florida, it will be an easy matter for other millions to go farther south. Americans will develop Cuba, the West Indies and Central America. That will make Florida the connecting link between North and South.

The man who plans great cities for Florida isn't taking chances. If he doesn't plan for great and rapid growth, he is taking chances. For Florida—only thirty-six hours distant by train from sixty millions of people—draws upon the national resources to fill East Coast cities with unexampled rapidity.

All East Coast cities will grow. Millions of Americans can now afford to live where living conditions are best. Stores, factories, railroads, men, money and ideas will follow them. Climate alone is sufficient to make the entire south-eastern coast of Florida one continuous city—a continuous city with many peaks of development.

There will be on the East Coast great fashionable resorts into which millions of people will flow each year. Boca Raton—especially favored by the Gulf Stream—will be one of them. It has climate, location, beaches, capable direction and the endorsement—financial and social—of the most distinguished company of Americans ever gathered together for such an enterprise.

It is this combination of many things—all of them good—which now makes Boca Raton the finest investment opportunity in America.

Mizner Development Corporation

MAIN OFFICE:
PALM BEACH, FLORIDA
PHONE 1193

| TEMPORARY MIAMI OFFICE, 133 E. FLAGLER ST. | MIAMI BEACH, 426 COLLINS AVE. · PHONE 868 | TEMPORARY TAMPA OFFICE, HILLSBORO HOTEL, PARLOR A | LAKE WORTH, 300 LAKE AVENUE |

OFFICE AT BOCA RATON

Developers of Boca Raton

A similar advertisement features an amusing portrait of the globe with the earth's population at the equator and Americans herding towards Boca Raton (by air, land, and sea). It claims "the population of the world is flowing towards the equator" and accurately portends "climate alone is sufficient to make the entire southeastern coast of Florida one continuous city." (BRHS.)

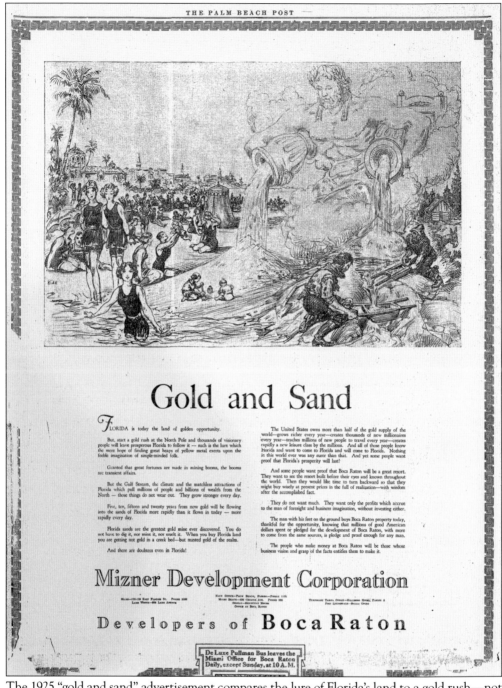

Gold and Sand

FLORIDA is today the land of golden opportunity.

But, start a gold rush at the North Pole and thousands of visionary people will leave prosperous Florida to follow it — such is the lure which the mere hope of finding great heaps of yellow metal exerts upon the feeble imagination of simple-minded folk.

Granted that great fortunes are made in mining booms, the booms are transient affairs.

But the Gulf Stream, the climate and the matchless attractions of Florida which pull millions of people and billions of wealth from the North — those things do not wear out. They grow stronger every day.

Five, ten, fifteen and twenty years from now gold will be flowing into the sands of Florida more rapidly than it flows in today — more rapidly every day.

Florida sands are the greatest gold mine ever discovered. You do not have to dig it, nor mine it, nor smelt it. When you buy Florida land you are getting not gold in a creek bed—but minted gold of the realm.

And there are doubters even in Florida!

The United States owns more than half of the gold supply of the world—grows richer every year—creates thousands of new millionaires every year—teaches millions of new people to travel every year—creates rapidly a new leisure class by the millions. And all of those people know Florida and want to come to Florida and will come to Florida. Nothing in this world ever was any surer than that. And yet some people want proof that Florida's prosperity will last!

And some people want proof that Boca Raton will be a great resort. They want to see the resort built before their eyes and known throughout the world. Then they would like time to turn backward so that they might buy wisely at present prices in the full of realization—with wisdom after the accomplished fact.

They do not want much. They want only the profits which accrue to the man of foresight and business imagination, without investing either.

The man with his feet on the ground buys Boca Raton property today, thankful for the opportunity, knowing that millions of good American dollars spent or pledged for the development of Boca Raton, with more to come from the same sources, is pledge and proof enough for any man.

The people who make money at Boca Raton will be those whose business vision and grasp of the facts entitles them to make it.

Mizner Development Corporation

MIAMI—115-120 EAST FLAGLER ST. PHONE 3338 MAIN OFFICE—PALM BEACH, FLORIDA—PHONE 1131 TEMPORARY TAMPA OFFICE—HILLSBORO HOTEL, PARLOR A
LAKE WORTH—606 LAKE AVENUE MIAMI BEACH—836 CHASEOE AVE. PHONE 383 FORT LAUDERDALE—BOCA OFFICE
 DELRAY—KESTWICK HOUSE
 OFFICE AT BOCA RATON

Developers of Boca Raton

De Luxe Pullman Bus leaves the Miami Office for Boca Raton Daily, except Sunday, at 10 A.M.

The 1925 "gold and sand" advertisement compares the lure of Florida's land to a gold rush—not an unsuitable metaphor. It assures that "Florida sands are the greatest gold mine ever discovered" and that the United States is growing wealthier every year, resulting in the rapid growth of the leisure class. "And all of these people know Florida and want to come to Florida and will come to Florida." (BRHS.)

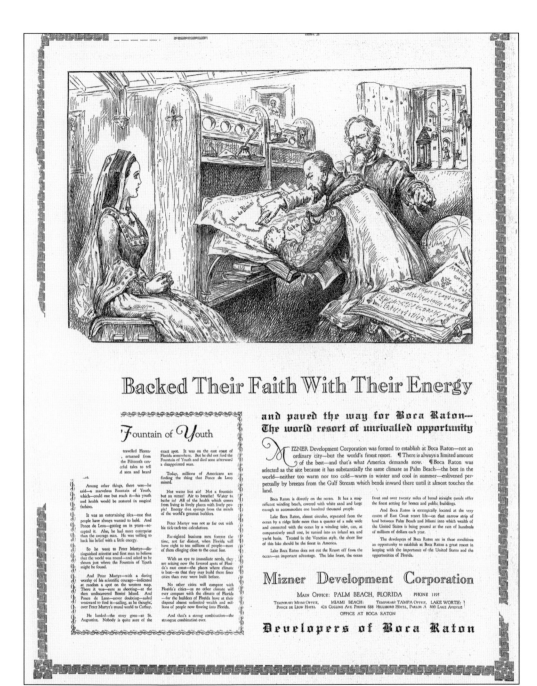

Many of the Mizner Development Corporation advertisements made reference to Boca Raton's supposed Spanish origins. Modern scholarship has shown that the original "Boca de Ratones" was an inlet actually located on what is now Miami Beach—not its present location. Alas, the tales of pirates and Spanish explorers employed by the boom-time developers are mere legends. Nonetheless, Peter Martyr and Ponce de Leon planning their voyage to search for the "fountain of youth," the stuff of Florida legends, is the inspiration for "farsighted businessmen" in this advertisement. (BRHS.)

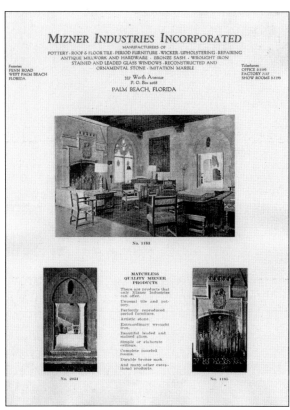

During the construction of the Everglades Club in Palm Beach, Mizner realized the lack of local suppliers for ironwork, tiles, and other necessary ornamental items for his Spanish-style designs. He created a series of companies called Mizner Industries in Palm Beach County. By the end of the 1920s, they were producing pottery, ironwork, cast stone (a cementitious mixture), roof and floor tiles, and furniture in the Spanish colonial style. This is the cover of one of the Mizner Industry catalogues. (BRHS.)

Mizner had a fascination with antiques and furnishings design in addition to his love of architectural detail. Here an elaborate lantern design is to feature gargoyle-like "eagles." The "artistic" Mizner's spelling is questionable as well. "Architrave" and "frieze" he could handle, but "height" is "hite." (BRHS.)

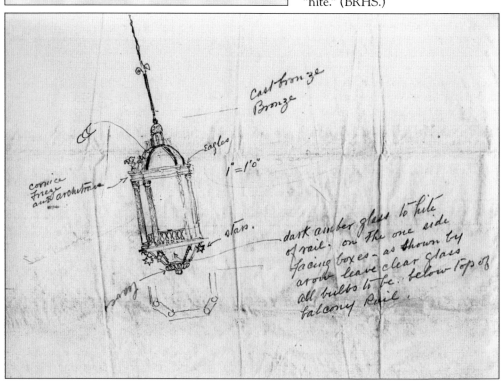

48

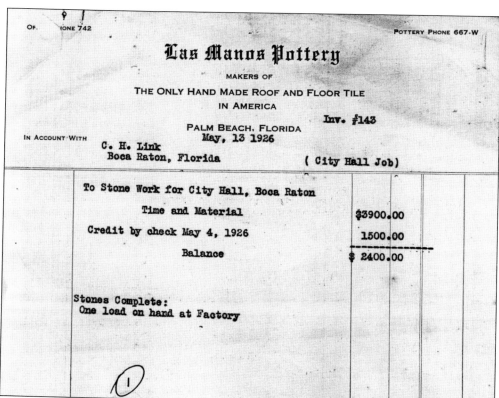

POTTERY PHONE 667-W

Las Manos Pottery

MAKERS OF

THE ONLY HAND MADE ROOF AND FLOOR TILE

IN AMERICA

Inv. #143

PALM BEACH, FLORIDA

May, 13 1926

IN ACCOUNT WITH

C. H. Link
Boca Raton, Florida

(City Hall Job)

To Stone Work for City Hall, Boca Raton	
Time and Material	$3900.00
Credit by check May 4, 1926	1500.00
Balance	$ 2400.00

Stones Complete:
One load on hand at Factory

One of the Mizner Industries was Las Manos Pottery, which produced decorative pottery for indoor and outdoor use. Many of the items were large jardinieres or urns to grace the many patios, porches, and elaborate gardens of Mizner's mansion and vias. He had his technicians work to perfect a certain shade of turquoise blue today known as "Mizner blue," as well as a distinctive mustard-yellow glaze. These were colors Mizner associated with the Mediterranean style he so often employed in his designs. Above, a rare receipt survives from the pottery for Boca Raton's town hall for "stone work," probably referring to the stoneware floor tiles. At right, the cover to one of the Las Manos catalogues features decorative garden ware. (BRHS.)

Handmade Pottery

MADE by

MIZNER INDUSTRIES INC.
337 WORTH AVE, PALM BEACH FLA.

Established 1919

Pottery of Character

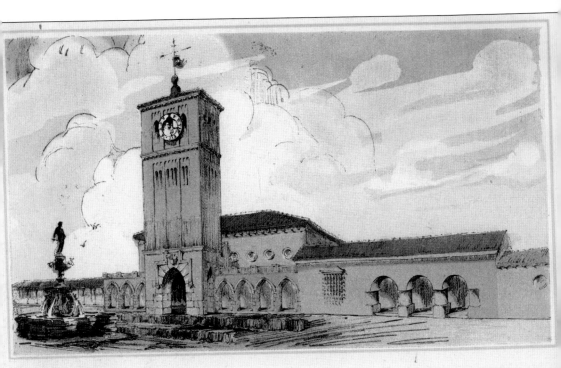

Imposing

in proportions and beautiful in every line and detail, this passenger station has been designed by Addison Mizner to accommodate the ever increasing flow of traffic into this City Beautiful of the Florida East Coast.

From 1895 until 1927, the Florida East Coast Railway was the only rail line serving South Florida. In 1925, the Seaboard Airline (SAL) Railroad planned an expansion of its service to Miami—and the promise of passenger service directly from New York, Chicago and other major cities. Mizner's plans included the drawings for Addison Station, a glamorous depot for the anticipated new railway that was to be sited in the western area of the Mizner development on Camino Real. Today this site would be on Camino Real just west of the interstate. SAL finally arrived in 1927 to much pomp, but no SAL passenger station was ever built in the then-small town of Boca Raton. (BRHS.)

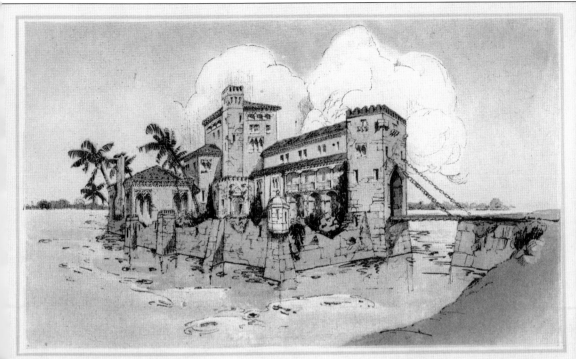

This is the Home

which Addison Mizner has planned for himself. The erection of so massive and stately a structure gives substantial evidence of Addison Mizner's faith in the future of this new resort. The chosen location is an island in Lake Boca Raton and this replica of an old-world castle will make an important contribution to the architectural splendor of Boca Raton.

One of Mizner's most glamorous proposed mansions was a home for himself to be built on Lake Boca Raton, Castle Mizner. The home was a similar design to his actual home, Villa Mizner, on Worth Avenue in Palm Beach; a four-story tower was to give him oceanfront views, and the drawbridge created a nice little medieval detail for greater privacy. Mizner promised to leave the castle to Boca Raton upon his death. Unfortunately, although it was fully designed with great detail, it was never constructed. The drawing, however, was often used in Mizner publicity advertisements and brochures. (BRHS.)

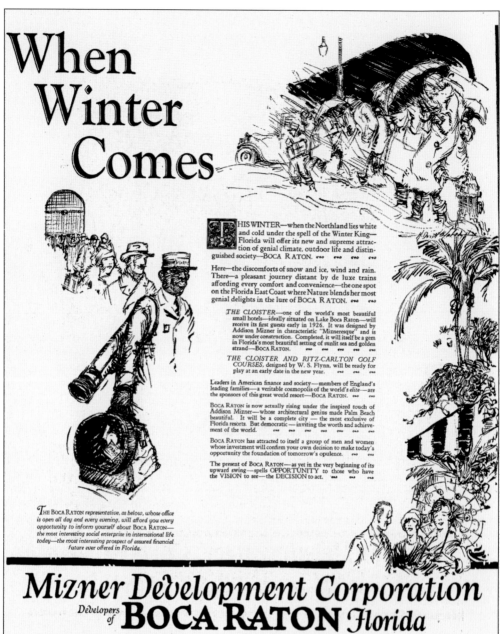

A major allure of Boca Raton, then as now, was the climate. "When Winter Comes" assures visitors, "When the northland lies white and cold under the spell of the Winter King, Florida will offer its new and supreme attraction of genial climate, outdoor life, and distinguished society—Boca Raton." The wealthy visitors who came during "the season" were quick to spread the joys of Boca Raton. It was warm, dry, quiet, and scenic, with abundant outdoor entertainments. Unfortunately, prospective land buyers coming in the summertime found very different conditions: no place to stay, high heat and humidity, and lots and lots of bugs. (BRHS.)

Mizner's plans for polo grounds at Boca were pure snob appeal—something he and the MDC publicity crew were quite good at: "For this is sportsland! The golf season is twelve months long. Rackets swing the whole year round. Polo time is all the time—it's always *June* at Boca Raton." The polo grounds allegedly laid out south of Camino Real did not materialize in the 1920s. However, years later, Boca Raton Hotel owner A. V. Davis finally made Mizner's dream a reality when he established the Royal Palm Polo Club south of Camino Real and east of Federal Highway in 1957. (BRHS.)

Spanish Art

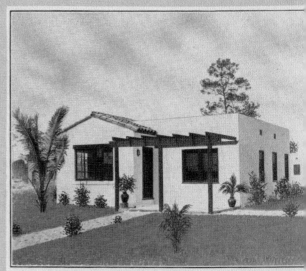

in Boca Raton homes adds a special charm to these dwellings in a land of tropical beauty where the soft-ness of the South makes life easy.

Contractor Harry Vought constructed a series of small bungalows for the Mizner Development Corporation along Northwest Seventh and Eighth Streets off Boca Raton Boulevard (Northwest Second Avenue). Today this neighborhood is known as Spanish Village. According to a contemporary advertisement, "these houses represent happy living conditions for the man who looks for comfort and convenience, coupled with a price that is not prohibitive." Although 100 were planned, only 22 were completed. Today many of the Spanish Village homes survive but are threatened by property values that would have amazed even the boom-time investors. (BRHS.)

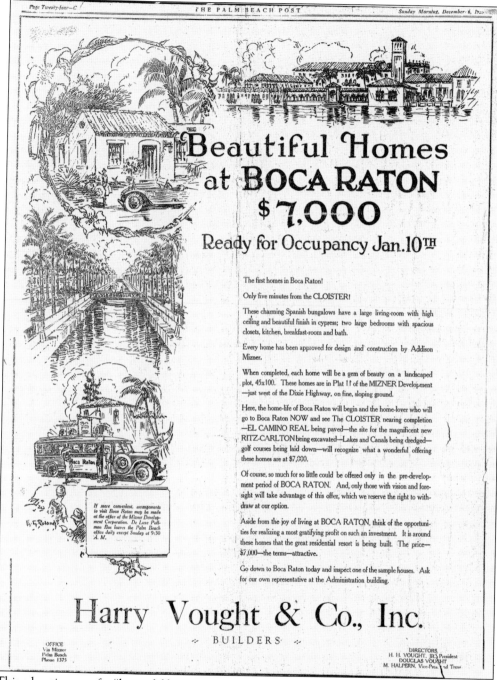

Beautiful Homes
at BOCA RATON
$7,000
Ready for Occupancy Jan. 10TH

The first homes in Boca Raton!

Only five minutes from the CLOISTER!

These charming Spanish bungalows have a large living-room with high ceiling and beautiful finish in cypress; two large bedrooms with spacious closets, kitchen, breakfast-room and bath.

Every home has been approved for design and construction by Addison Mizner.

When completed, each home will be a gem of beauty on a landscaped plot, 45x100. These homes are in Plat 11 of the MIZNER Development —just west of the Dixie Highway, on fine, sloping ground.

Here, the home-life of Boca Raton will begin and the home-lover who will go to Boca Raton NOW and see The CLOISTER nearing completion —EL CAMINO REAL being paved—the site for the magnificent new RITZ-CARLTON being excavated—Lakes and Canals being dredged— golf courses being laid down—will recognize what a wonderful offering these homes are at $7,000.

Of course, so much for so little could be offered only in the pre-development period of BOCA RATON. And, only those with vision and foresight will take advantage of this offer, which we reserve the right to withdraw at our option.

Aside from the joy of living at BOCA RATON, think of the opportunities for realizing a most gratifying profit on such an investment. It is around these homes that the great residential resort is being built. The price— $7,000—the terms—attractive.

Go down to Boca Raton today and inspect one of the sample houses. Ask for our own representative at the Administration building.

If more convenient, arrangements to visit Boca Raton may be made at the office of the Mizner Development Corporation. De Luxe Pullman Bus leaves the Palm Beach office daily except Sunday at 9:30 A. M.

Harry Vought & Co., Inc.
·:· BUILDERS ·:·

OFFICE
Via Mizner
Palm Beach
Phone 1375

DIRECTORS
H. H. VOUGHT, JR., President
DOUGLAS VOUGHT
M. HALPERN, Vice-Pres. and Treas.

This advertisement for "beautiful homes at Boca Raton" alludes to the Harry Vought–built Spanish Village homes "just west of the Dixie Highway, on fine sloping ground." These were the most affordable of the Mizner Development housing projects, priced at $7,000 and up. They featured "large" living rooms with high ceilings with cypress details, two bedrooms with closets, kitchens, "breakfast room," and bath on 45-by-100-foot lots. (BRHS.)

55

Apartments

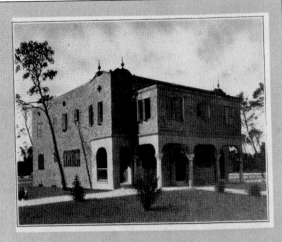

are already occupied in Boca Raton and a need for more is evidenced. The private investment of builders signifies the stability of the Mizner Development.

Mizner's Dunagan Apartments were completed in 1926 on De Soto Road, a street running north from Camino Real and overlooking the golf course of the Cloister Inn, Mizner's resort hotel. It was the only Mizner-designed apartment building to be completed in the Boca Raton development. The apartment building fell victim to the expansion of the golf course at the Boca Raton Club in later years. (BRHS.)

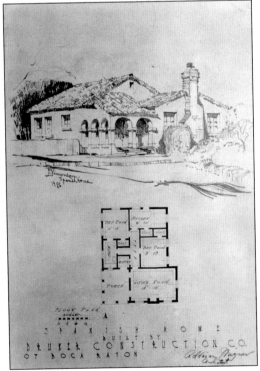

This plan for a "Spanish Home" was one of several Mizner designed for Dr. Maurice Druker. Druker planned a small development on land south of Camino Real and east of Federal Highway in an area that is now part of the Royal Palm Yacht and Country Club. At least four houses were constructed but were demolished by the 1960s. (BRHS.)

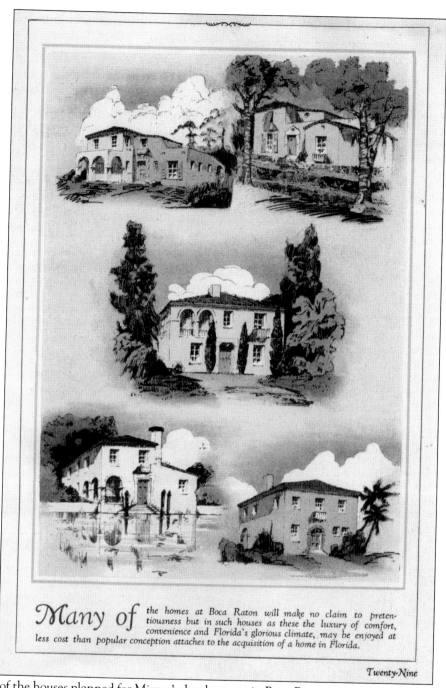

Many of
the homes at Boca Raton will make no claim to pretentiousness but in such houses as these the luxury of comfort, convenience and Florida's glorious climate, may be enjoyed at less cost than popular conception attaches to the acquisition of a home in Florida.

Many of the houses planned for Mizner's development in Boca Raton were never constructed. It was not so for the houses of the Old Floresta neighborhood, today one of the city's historic districts. The Robinson Company received the contract to begin 29 homes in a neighborhood west of the El Rio Canal on West Palmetto Park Road. The houses were planned as a modest version of the Mizner style, with multi-level roofs, stuccoed walls, ironwork, and plenty of tile. The homes were intended for the executives and directors of the Mizner Development Company. This drawing from an MDC brochure features some of the models still seen in Old Floresta today. (BRHS.)

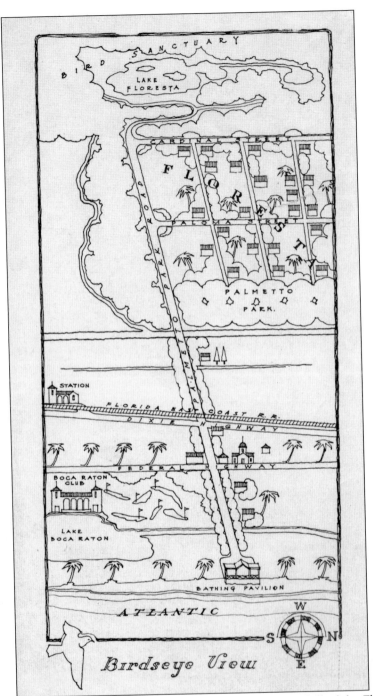

The Robinson Company was unable to complete the construction of all of the Floresta homes before money ran out in the "bust" of 1927. The property returned to the original landowners, one of whom was Herman von Holst, who ensured the completion of the subdivision. He also named it Floresta, which translates to "a delightful rural place," and assigned the bird and flower names to the streets. This map is from a brochure from an advertising tract from the early 1930s. (BRHS.)

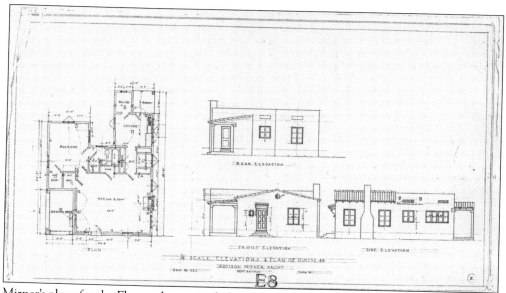

Mizner's plans for the Floresta homes included 10 models, some one, others two stories. Most of these models were constructed, although many homes featured a "reverse" of the plan or were otherwise altered during actual construction. Most of the homes today have been added on to—a necessary accommodation to modern living. This is the Mizner design for house "H." (BRHS.)

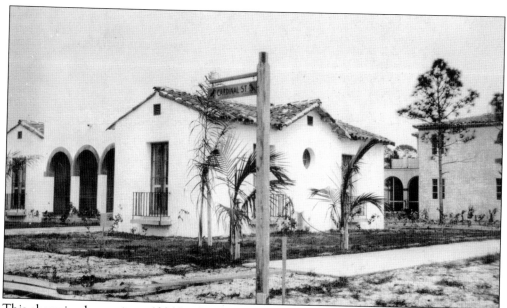

This charming home sits at 130 Northwest Ninth Street (Cardinal Street). It represents one of the smaller, one-story homes and is typical of Mizner's Floresta plans with plain facades, rough-finished stucco, wrought-iron balconies and uneven roofs with barrel tile. The house at the rear is the home of Von Holst. The photograph was taken in February 1928. (BRHS.)

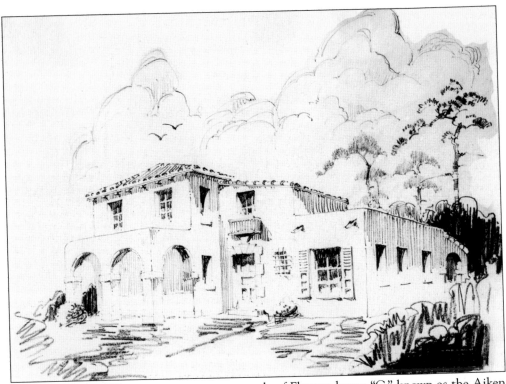

The home at 801 Hibiscus represents an example of Floresta house "C," known as the Aiken House after longtime owner Fred. C. Aiken. Fred and his wife, Lottie, came to Boca Raton from Chicago at the end of the Florida land boom in 1928. Aiken was another one of the original landowners who acquired ownership of the houses in the subdivision along with Von Holst and partner John Verhoeven. In 1929, Aiken became Boca Raton's mayor, serving until 1938. Above is a rendering for house "C." Below, Fred (left) and Lottie Aiken (right) pose with a friend on the porch of their home in 1928. (BRHS.)

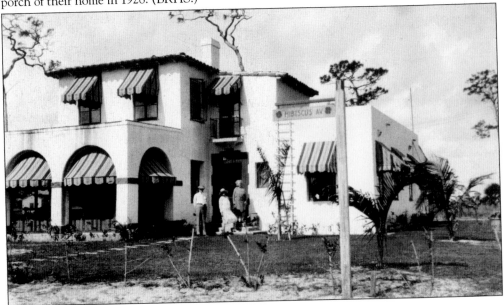

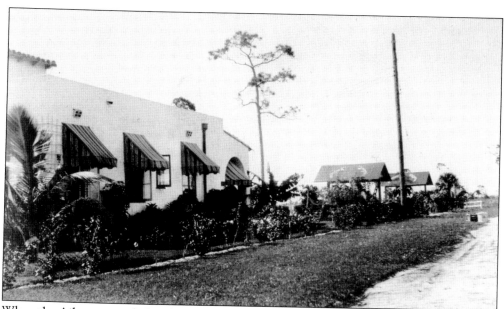

When the Aikens arrived, they found the Floresta neighborhood badly damaged by several major hurricanes. With their partners, they began repairs and proceeded to tackle the landscaping. Today Old Floresta is well-known for its beautiful gardens as well as beautiful homes. Above, the Paloma Avenue side of the house reveals the large garden and, amazingly, empty lots in the background in 1928. At right, Fred (in nifty golfing knickers) sneaks a smooch with Lottie outside the window of the home in the late 1920s. (BRHS.)

BOCA RATON

Florida's Wholly New Entirely Beautiful World Resort

MIZNER DEVELOPMENT CORP
Palm Beach, Florida

All the Florida developments required a showpiece hotel. Mizner planned a giant beachfront hotel for the foot of Camino Real, today the site of the Beach Club. Before the Ritz Carlton could be constructed, he built a smaller hostelry on the western shores of Lake Boca Raton to house prospective buyers and named it the Cloister Inn. Today this is the Boca Raton Resort and Club. This pamphlet features the beautiful little hotel drawing visitors to the glamorous new resort community, *c.* 1926. (BRHS.)

Three

A Palace for Boca Raton

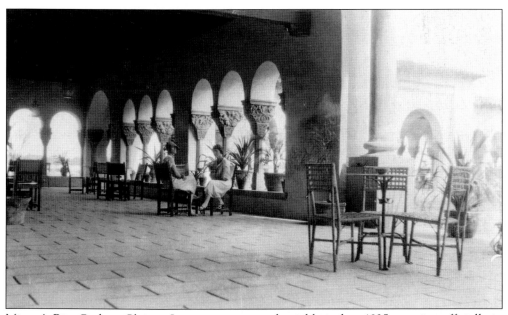

Mizner's Ritz Carlton Cloister Inn was constructed quickly in late 1925, opening officially in early 1926. It was probably the most elegant structure many local residents had ever seen. Here Harriette Gates and Helen Howard enjoy the beauty of the cloister of the Cloister Inn. They are seated in the northern portion of the cloister, outside what was then the entrance to the dining room, *c.* 1927. (BRHS.)

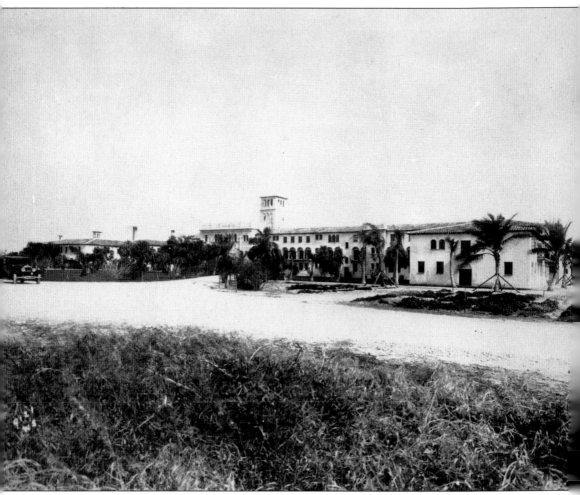

The Cloister Inn was "simple to severity in its whole yet rich in delights," according to one critic. "The walls of the building looked as if they had reflected the passing history of ages," said the *Palm Beach News*. The public and guest rooms were connected by a beautiful lakefront cloister framing a central courtyard. The tower provided a room with a view of the nearby ocean and Lake Boca Raton and was supposedly modeled after the Giralda Tower at Seville. The entrance to the hotel faced west, shown in this view. Notice the newly planted palm trees at right. Today this forms the eastern wing of the Boca Raton Resort and Club. (BRHS.)

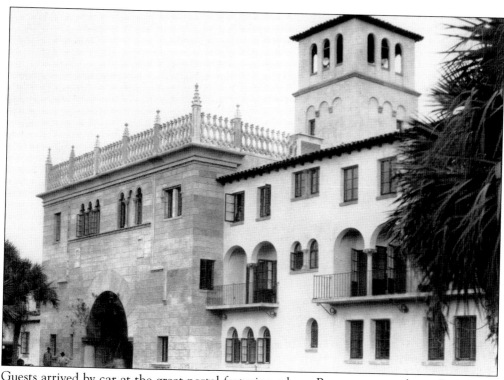

Guests arrived by car at the great portal featuring a large Romanesque arch on the western facade of the hotel. This image, made c. 1926, reveals the beautiful casement windows, balconies, and tower of the western facade. Groundskeepers hover by the main entrance at lower left, and someone peeks out of a window on the third floor. (BRHS.)

In December 1925, Mizner hosted a Christmas Eve dinner at the hotel for "all the right people" from Palm Beach society. The great architect Stanford White's widow, Bessie Smith White, was amongst them. She was quoted as observing, "This building is superb." In this image, the evening's guests sit amid the yet-unplastered walls of the cloister. Addison Mizner is on the far left in profile, with cup in hand. Wilson leans back, laughing, in his chair at the center right. (BRHS.)

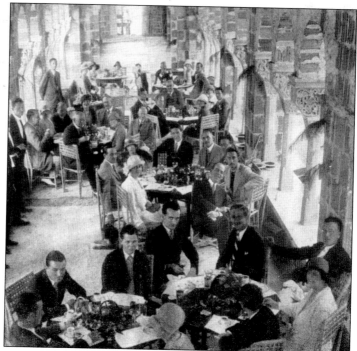

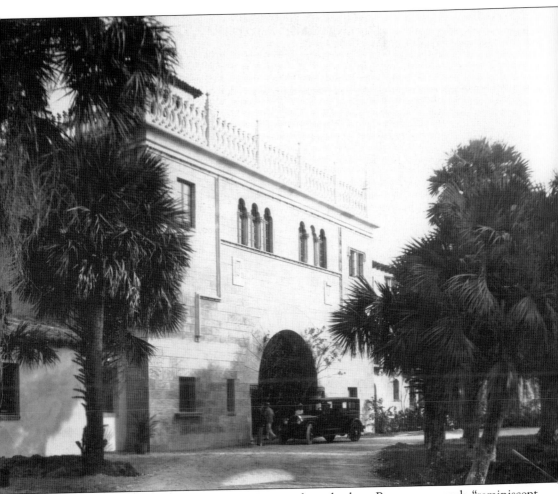

Entrance to the main lobby of the Cloister Inn was through a large Romanesque arch, "reminiscent of the entrance gate of the University of Salamanca, near Madrid," according to one newspaper report. "It is not a rigid stereotyped copy, however, but is recreated in a blend of soft brown stone of exceptional delight." Architects Schultze and Weaver paid homage to this design with a similar portal on the western facade of the 1929 addition to the hotel. Visitors were next greeted by an elaborate 26-foot-high door also inspired by the university. In this photograph, visitors arrive by car while liveried bellhops assist with the luggage. This view is looking southeast from the current main entrance to the Boca Raton Resort and Club. (BRHS.)

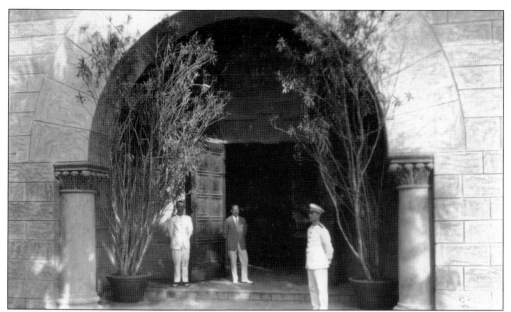

The two-story lobby of the Cloister Inn featured heavy cypress beam ceilings, a "medieval style" balcony that wrapped around two walls, and arched doorways in the interior. Rough white plaster decorated the walls. Moroccan-style lanterns and Spanish-style iron sconces provided lighting. The "Mizner lobby" looks much as it once did, occasionally serving as the main entrance when the current main lobby is undergoing renovation or repair. Above, a close-up of the entrance portal shows staff in attendance. Below, an interior view of the lobby is viewed from just inside the door in 1926. (BRHS.)

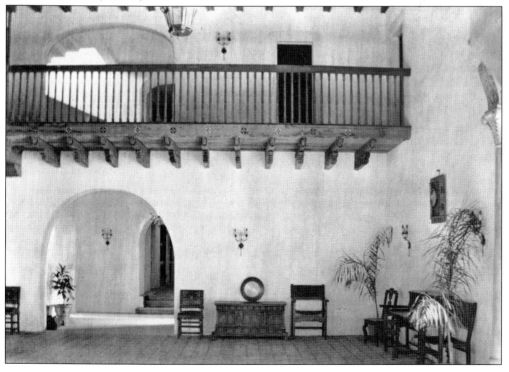

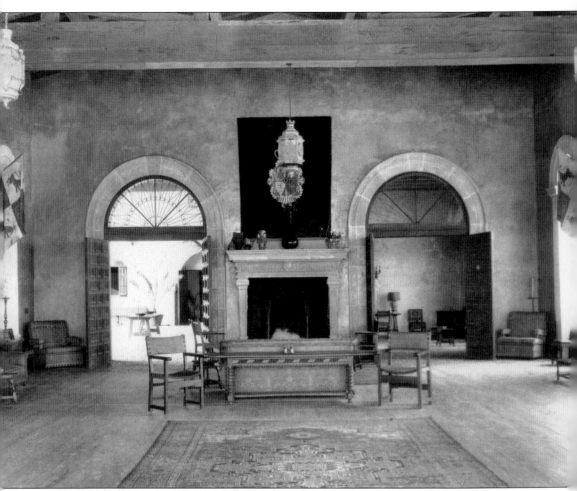

Because of financial difficulties faced by the Mizner Development Corporation in late 1925, Mizner employed items from his personal collections in the furnishing of the public rooms of the hotel. According to a contemporary newspaper story, "austerity is the keynote of design and decoration of the Cloister." In addition to actual antiques, the hotel was furnished with items produced by the Mizner Industries factories in West Palm Beach. This view features the ballroom of the Cloister Inn, a large open space that overlooked the waters of Lake Boca Raton. In the "great hall," on the opening eve of the hotel, "logs were burning in a huge fireplace, into which a man might walk up-right. Shields placed along the walls of the great high-ceilinged beamed room held clusters of bright Spanish flags, spoils of wars untold." The fireplace was the only such in the original Cloister Inn. Today it is a feature in Bar Luna at the Boca Raton Resort and Club. (BRHS.)

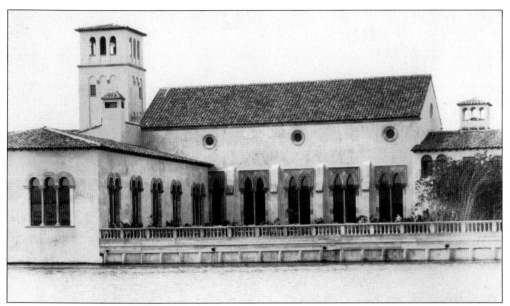

This image from 1926 highlights the east facade of the ballroom, at left, and the dining room (beyond the patio, at center), at what was the northern end of the hotel. In 1928–1929, the hotel was enlarged and these rooms transformed into guest lounges. The ballroom was remodeled and extended out over the water by Palm Beach architect Marion Syms Wyeth in the mid-1930s. (BRHS.)

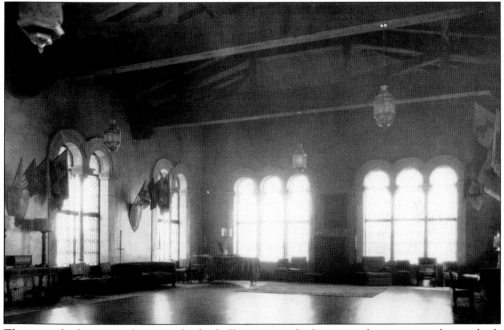

This view looking east from inside the ballroom reveals the original eastern windows, which overlooked Lake Boca Raton. The heavy beamed ceiling was characteristic of Mizner's public rooms. A 1926 newspaper article reported that "the blues and greens of the tropical waters are reflected in the stained glass windows." Today this room serves as one of the Boca Raton Resort and Club's several restaurants. (BRHS.)

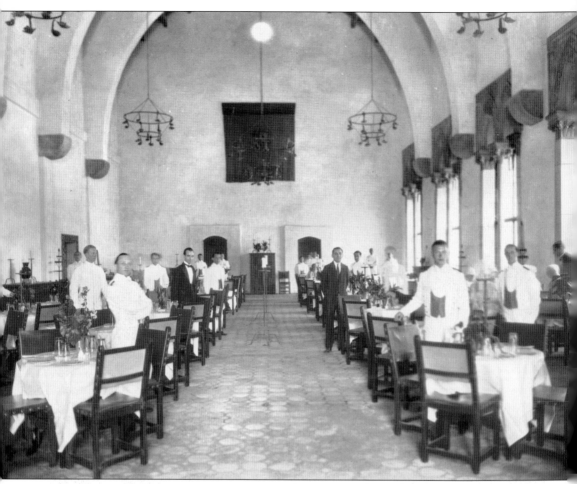

The dining room of the Cloister Inn was of particular note to visitors. Supposedly modeled upon a 15th-century hospital at Vich in Catalonia, it featured arched bays supporting ceiling beams and sapling poles. "Lavabos," or standing washbasins, lined the walls for the convenience of the guests in ancient Spanish style. The studded leather-covered chairs, standing iron candleholders (called "prickets"), chandeliers, and floor tiles are examples of Mizner Industry products. Some of the chairs and prickets are today in the collection of the Boca Raton Historical Society. At the Christmas Eve opening dinner, "red-coated, gold braided servitors, responding in French and Spanish to whispered queries" served a "truly Lucullan repast" (*Palm Beach Post*, February 8, 1926). (BRHS.)

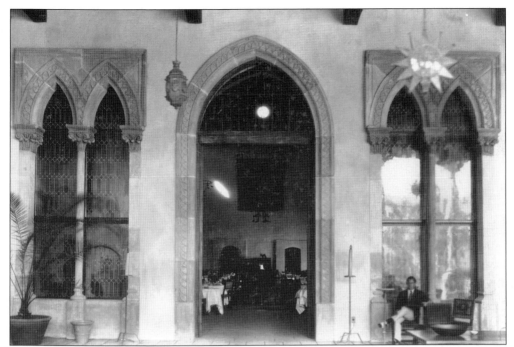

The entrance to the dining room faced south, opening on to the cloister and the central courtyard. The sides and ends featured intricate stained-glass windows in green, yellow, and rose. They gave, along with the red-tiled floors, "supporting warmth to the soft biscuit tones of the walls," according to the society column of the February 8, 1926, *Palm Beach Post*. Above, a visitor enjoys the breezes outside the south entrance to the dining room. Note the novel star-shaped lantern at upper right, removed during the 1929 remodeling of the hotel. Below is a close-up of the east-facing windows of what was considered the most dramatic room at the hotel. They are today only partially visible from the second-floor Mizner Room. (BRHS.)

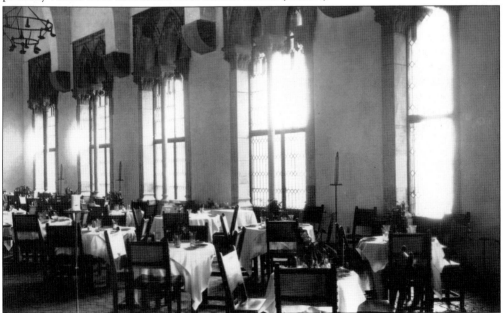

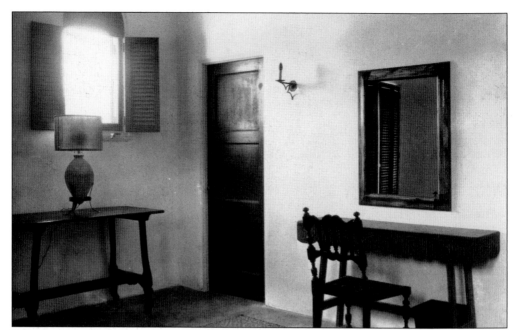

In stark contrast to the public rooms were the rather monastic guest rooms. They featured many Mizner Industry pieces such as decorative painted headboards, ironwork, and pottery. Each room was furnished differently. In this view of a guest room, the bedroom floor appears to be polished but plain concrete. A Mizner Industry table and "olla" lamp (made from cast concrete to resemble an antique olla) stand at left. (BRHS.)

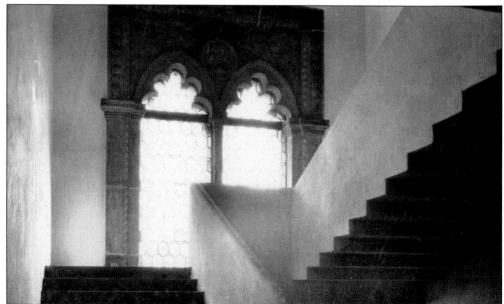

The southeastern wing of the Cloister Inn was demolished in the late 1960s when hotel owners created a modern 26-story tower to accommodate the growing convention trade. This elegant window, in the stairwell between the first and second floor at the south end of the original Cloister Inn, was just beyond the reach of the bulldozers. It can still be seen in the southeastern side of the old part of the hotel. (BRHS.)

One of the key attractions of the new resort was golfing. Two courses were completed by 1926 on the grounds of the Cloister Inn. In this photograph from the January 1927 *Boca Raton Record*, Capt. Ernest F. Carter (left), a ranking amateur champion, awaits C. E. Karstrom (center) and ? McKenzie (right), winter guests from Chicago. The western facade of the Cloister Inn is visible in the background. (BRHS.)

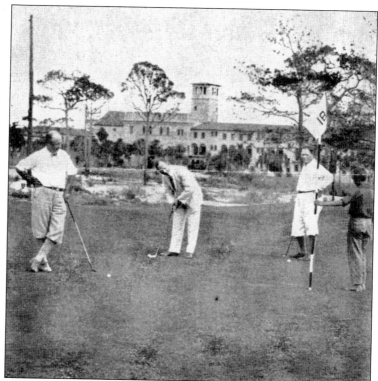

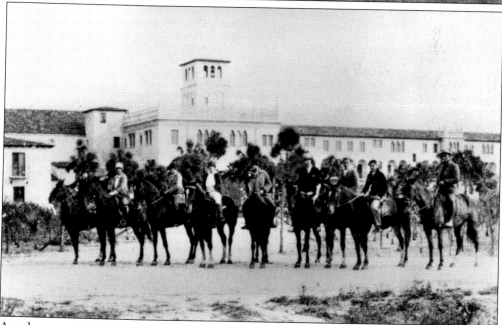

Another sporting activity aimed at high society offered on hotel grounds was hunting. The Boca Raton Hunt Club was organized in January 1927 with 55 members. The first hunt netted an eight-point buck and a large bobcat. One of the earliest activities of the members was to ride to greet the first passenger service of the Seaboard Airline Railroad, the *Orange Blossom Special*. Here riders line up outside the main entrance to the hotel in January 1927. (BRHS.)

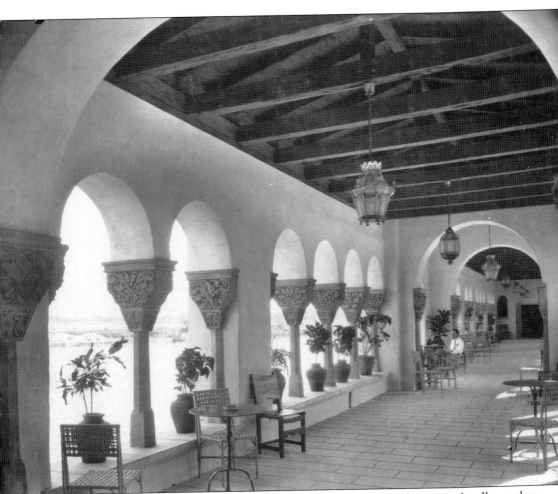

Connecting the public rooms at the Cloister Inn was the cloister itself, a covered walkway that overlooked the central courtyard and Lake Boca Raton. It was "such as the priests of old trod with sandaled feet," according to Mizner publicity. The arches were supported by Gothic columns featuring foliage and exotic creatures and birds. Local legend claims that the columns were installed upside down; however, they simply reflect the Gothic design. Mizner publicity also claimed that the beamed ceiling and carved brackets over the columns were originally a part of the University of Seville. Exotic lanterns, simplistic furnishings, and a tiled floor completed the monastic look. The cloister no longer directly overhangs the lake, the seawalls having been extended and terraces added to the eastern facade in the 1950s. Originally the cloister was an L shape running north and south as well as joining the "great hall" or ballroom and the dining room to the loggia. The northern section was filled in during later additions. (BRHS.)

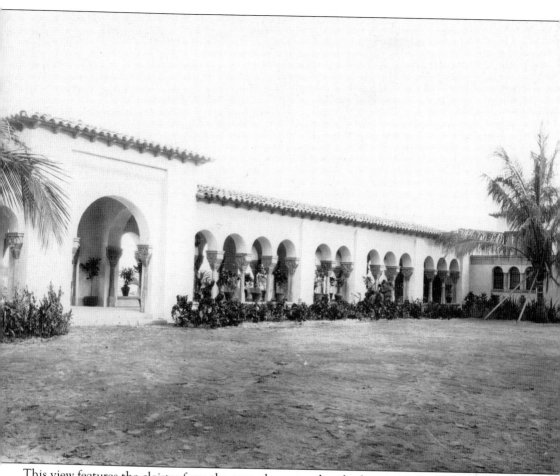

This view features the cloister from the central courtyard, today known as the Cloister Garden, looking south and east from the Mizner loggia. The portal at left was echoed on the lake view and provided an appropriately ornate yacht landing. Open to the sea breezes for many years, the cloister has long since been enclosed with glass windows in concession to modern guests' demand for air-conditioning. Note that the Cloister Garden, an elaborate Persian-inspired layout with water channels and fountains, did not exist when the Cloister Inn first opened. The rushed hurry to construct and open the hotel allowed little time for elaborate landscaping. A newly planted coconut palm at far right, bananas, and unrecognizable shrubs constitute the "tropical landscaping" at the new hotel. (BRHS.)

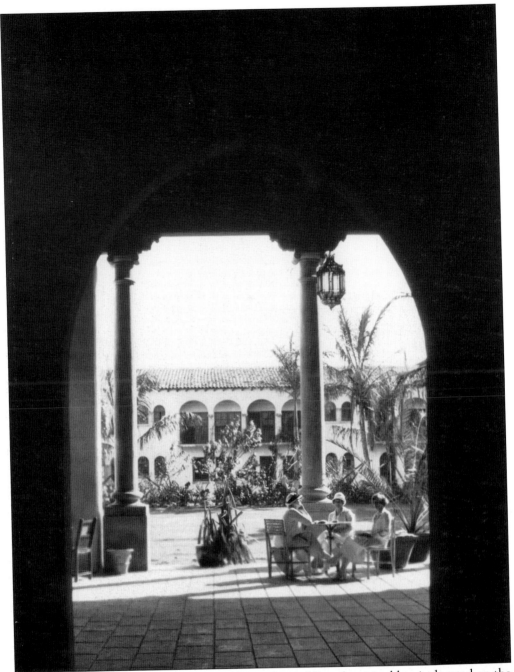

One of the least changed sections of the Cloister Inn is Mizner's original loggia, located on the northwest corner of the Cloister Garden today. Of supposed 13th-century-inspired design, it featured high ceilings with heavy beams and giant columns. Moroccan-style lanterns and tile floors carried out the Spanish theme. Lunching ladies take their leisure at tables and chairs manufactured by Mizner Industries for the hotel. They look south out onto the courtyard, now the Cloister Garden. In the background is visible the southeastern wing of the hotel, demolished for construction of the tower in the late 1960s. (BRHS.)

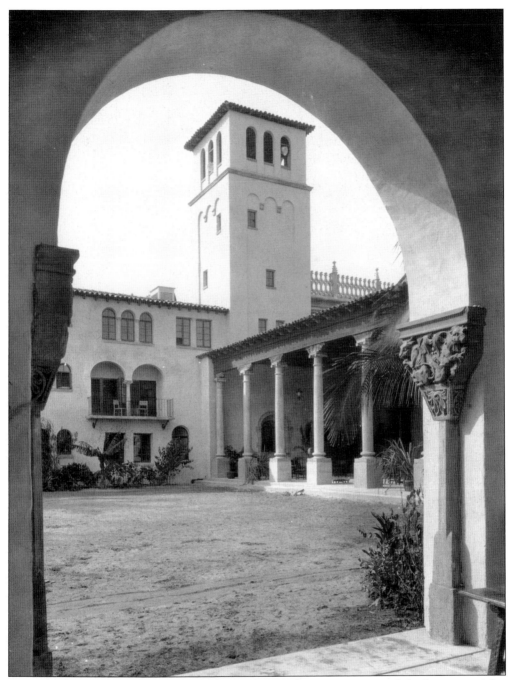

An arched opening of the lakefront cloister frames the exterior view of the loggia, at right. Also in view are the east side of the tower over the lobby and a portion of the western wing of the Cloister Inn, where "little balconies giving from the chamber of the second floor, invite serenaders," according to MDC publicists. The future Cloister Garden appears to be largely compacted sand when this photograph was taken. Also visible at near right is a close-up view of the capital of one of the Gothic arches of the cloister. A fanciful bull and lion scratch at the edges of each side. (BRHS.)

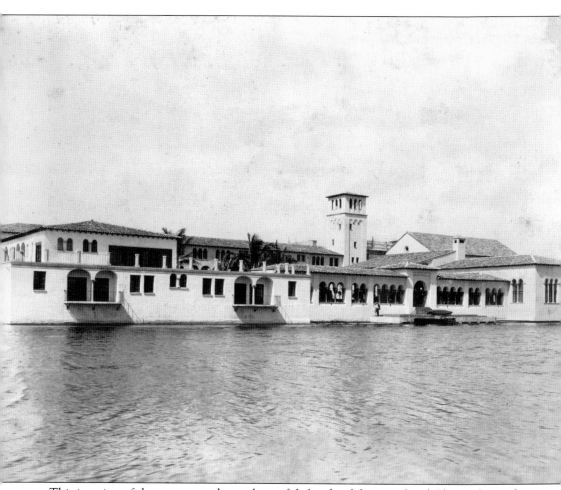

This is a view of the eastern, and most beautiful, facade of the completed Cloister Inn, taken *c.* 1926. At left were the most exclusive guest rooms, featuring direct views of Lake Boca Raton. This is the portion of the hotel demolished for the 1969 tower. At right of center is the cloister, then directly on the water and featuring a yacht landing at the central portal. At far right on the water is the eastern wall of the ballroom or great hall. This room was expanded out into the lake by architect Marion Syms Wyeth in the mid-1930s. Today this facade features a veranda and expanded seawall and is no longer directly on the water. (BRHS.)

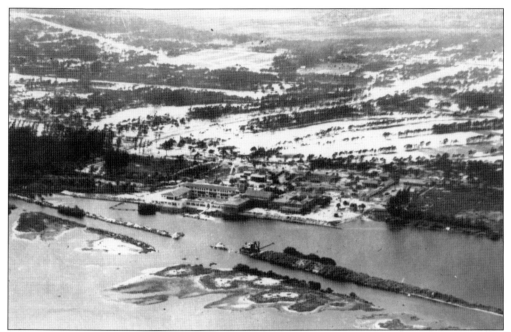

This aerial view shows the Cloister Inn under construction late in 1925. The odd lines of trees in the sugar sand represent the future golf course beyond the hotel. Camino Real is also visible as a diagonal line from lower left to upper right. Notice the old East Coast Canal, a channel right through the center of Lake Boca Raton, below. Dredges are actively engaged in removing the bulkheads and natural silting in the lake. (BRHS.)

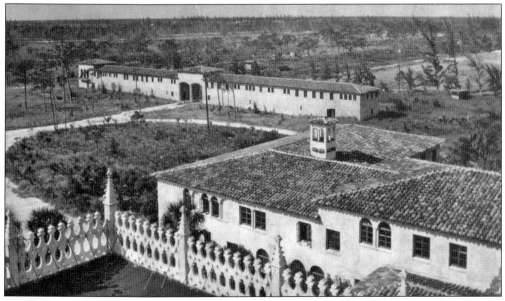

In addition to the hotel building, a number of supporting outbuildings were constructed by the Mizner Development Corporation on hotel grounds. This is a view of the garages and servant quarters, which stood to the northwest of the original Cloister Inn. The view, taken from atop the tower, looks northwest on hotel grounds to "downtown" Boca. The garage building, a Mizner original, was finally demolished in the 1960s. (BRHS.)

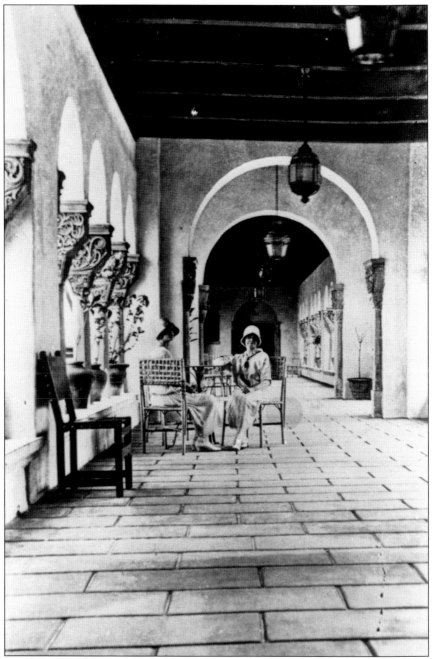

Boca Ratonians Harriette Gates (left) and Mary Driscoll (right) enjoy the breeze in the elegant cloister of the Cloister Inn overlooking Lake Boca Raton c. 1927. One of the studded dining room chairs (many of which are now in the collections of the Boca Raton Historical Society) stands at left. The ladies sit in garden-style furniture, which likewise appears in Mizner Industry catalogues. Notice the eclectic mix of Moroccan-style lanterns, imported by one of Mizner's decorators. Once Clarence Geist purchased the Cloister Inn and reopened it as the Boca Raton Club, it became a private resort. Only hotels guests and members (and staff) were allowed inside its hallowed halls, except on rare occasions. (BRHS.)

Four

THE "BOOM"

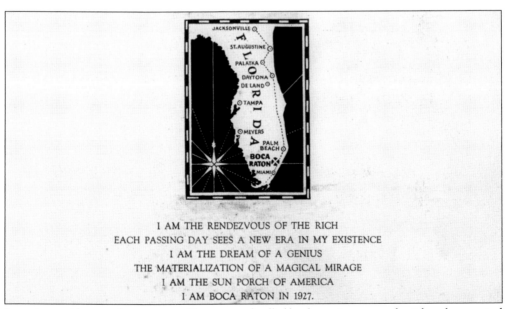

I AM THE RENDEZVOUS OF THE RICH
EACH PASSING DAY SEES A NEW ERA IN MY EXISTENCE
I AM THE DREAM OF A GENIUS
THE MATERIALIZATION OF A MAGICAL MIRAGE
I AM THE SUN PORCH OF AMERICA
I AM BOCA RATON IN 1927.

Longtime residents and newcomers alike were enthralled by the excitement and quick cash generated during Florida's 1920s boom. The Mizner Development Corporation was one of many projects launched in the area of Boca Raton and Delray Beach. This Mizner Development advertisement sums up the supreme confidence exuded by town fathers and local citizens—despite the boom's impending demise in 1927. (BRHS.)

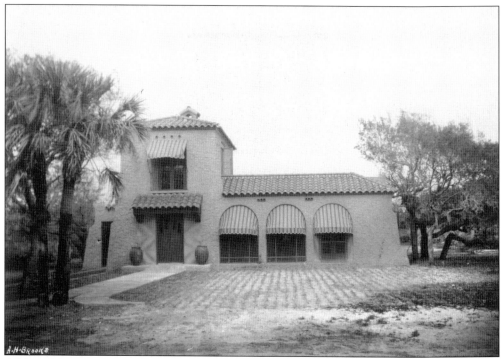

Addison Mizner was one of many architects working in what is now known as the Mediterranean Revival style in the 1920s. Beautiful Spanish-style homes were a hallmark of the era—de rigueur for successful local businessmen. Pioneer realtor Harley Gates had this lovely home, called Morada Bonita, literally "pretty home or abode," constructed for his family on the north side of Palmetto Park Road and east of the Intracoastal bridge. At the time, he had no immediate neighbors to bother him. The view above was taken in 1926 by photographer A. H. Brooks; the image below is a contemporary view of the back yard. Note the grass seedlings in the yard. (BRHS.)

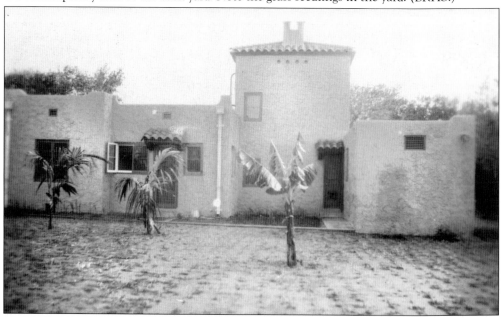

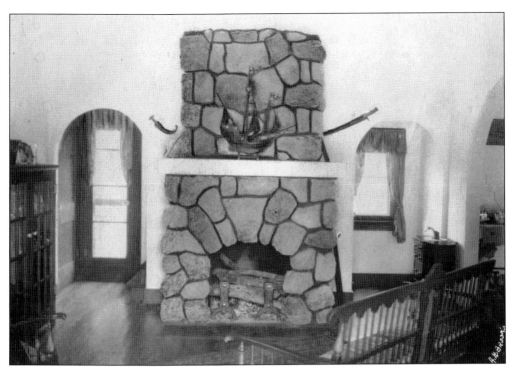

An unusual interior view highlights the great stone fireplace of Morada Bonita and some of the antiques collected by Mr. and Mrs. Gates in this photograph by A. H. Brooks taken in 1926. Below, Imogene Gates (left), Patsy Nelson (center), and Buddy Gates (right) play in the backyard of the house with their dog, at left. The backyard also featured a fishpond and low stuccoed wall. The latter would at least have partially helped to keep the "wilderness," which still surrounded the home, at bay. In ensuing years, the home became a retail establishment; it has recently been restored and still stands as a beautiful reminder of a glamorous era. (BRHS.)

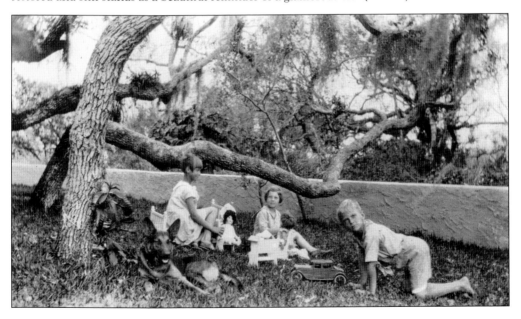

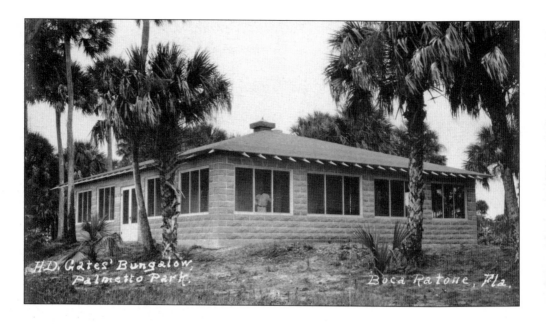

Harley Gates's first Boca Raton home was a cast concrete block, West Indian–style bungalow called Palmetto Park Plantation, built c. 1914. It was located at the northwest corner of the current Palmetto Park Road bridge over the Intracoastal and is why Palmetto Park Road is so named. In about 1923, Canadian Stanley Harris purchased the home and "Mediterraneanized" it by adding two rooms and a tower. He also built a wall along Palmetto Park Road and painted both pink, naming the new abode Casa Rosa. Casa Rosa fell to the wrecking ball in the late 1960s. Above is the rustic Palmetto Park Plantation, c. 1915, and below is the beautiful landscaped Casa Rosa. (BRHS.)

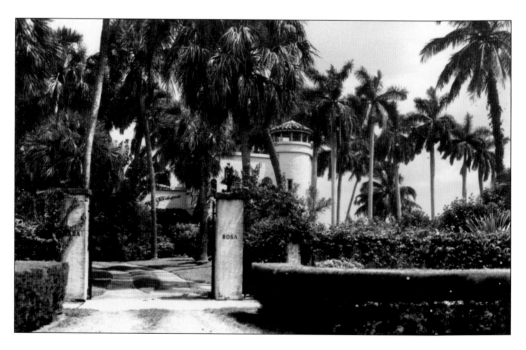

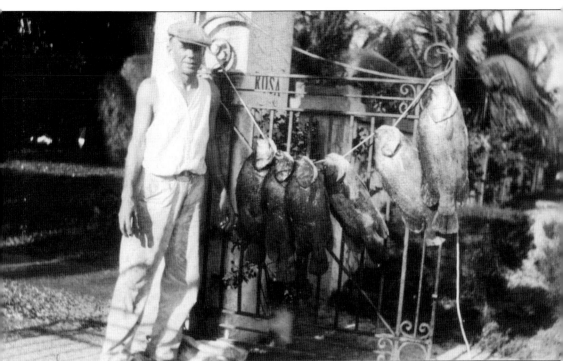

The gates of Casa Rosa served as a community landmark, located as they were adjacent the main bridge over the Intracoastal Waterway in Boca Raton. The wall and gates actually survived on the site long after the house was demolished. Later a nightclub called the Wildflower was built on the site. Unoccupied for many years now, the valuable site remains unused as of this writing. Here a Mr. Schmidt, known as "Smitty," poses with his catch at the entrance drive to the home. Smitty reportedly "lived in a palmetto shack," a bit unusual during such prosperous times. Perhaps he was a confirmed beachcomber. (BRHS.)

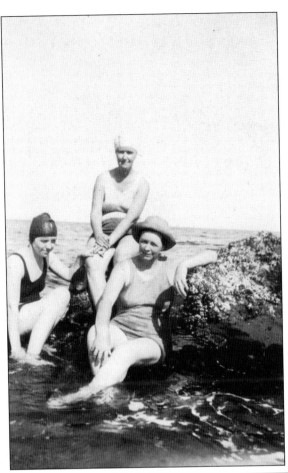

South Florida's miles of beautiful beaches had little allure for early settlers, who were more concerned with matters like agriculture and living near major transportation routes. Before the Palmetto Park Bridge was constructed in 1918, the only access to the beach was by boat. With the dawn of the 1920s and the coming of the Florida land boom, local beaches became a serious draw for investors and tourists. At left, Floy Mitchell (left), Mabel Tappan (center), and Peg Young (right) enjoy a dip in 1927. Below, Mrs. L. C. Nelson, friend of the Gates family, poses with the Gateses' dog on Boca's beach in the mid-1920s. (BRHS.)

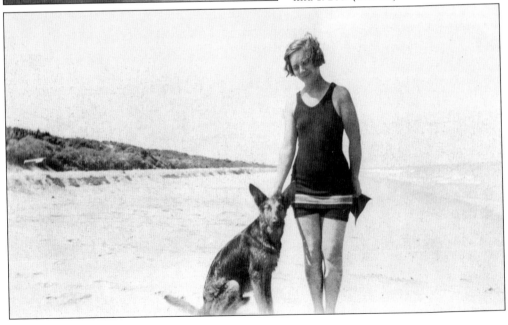

The Beach

stretches its golden sands for more than two miles; the warm waters of the Gulf Stream, three miles out, keep the surf always at inviting temperature.

Despite the little pavilion and beach at the foot of Palmetto Park Road, the Mizner Development Corporation required "ritzier" accommodations for the guests at the Ritz Carlton Cloister Inn. Early in 1926, Mizner Beach was established on the site of the planned Ritz Carlton beachfront hotel (which never materialized) north of the inlet. "Spanish cabanas" were constructed there decorated with "vivid hangings." Guests were served meals and dainty sandwiches by hotel staff. Above, a page from an MDC brochure features a boardwalk and the sides of two cabanas at the beach. Below, Buddy and Imogene Gates and the family dog play on the sand below the cabanas, c. 1926. Notice the high bluff, for which Boca Raton was then famous. (BRHS.)

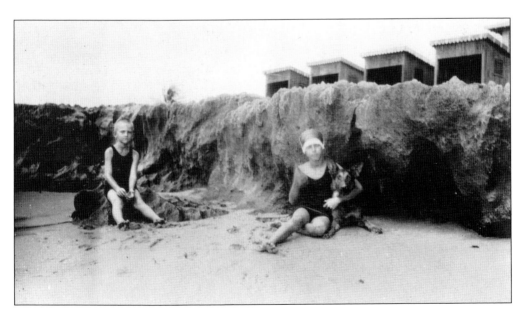

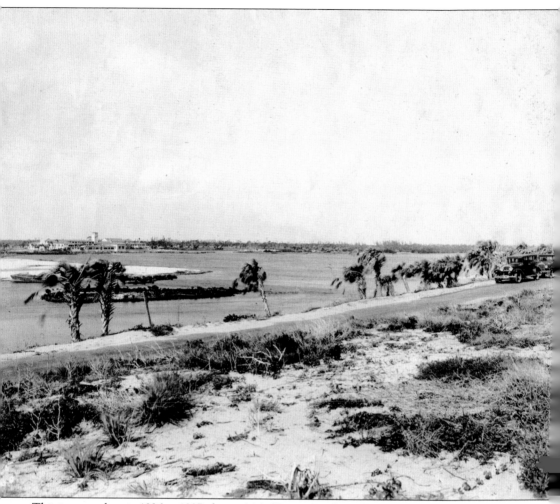

This image, taken in 1926 or 1927, shows A1A (Ocean Boulevard) north of the Boca Raton inlet. At left is Lake Boca Raton, with the newly completed Cloister Inn visible in the background. The photographer is standing just north of the site of the Boca Ratone by the Sea casino, which was demolished in the 1926 hurricane. The original inlet bridge is also to the left of the photograph, out of view. Two cars, one perhaps belonging to the photographer, are parked atop the bluff on the highway at right. (BRHS.)

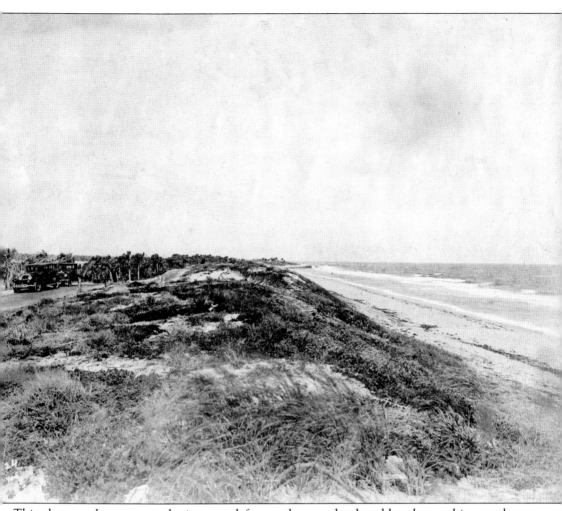

This photograph, a mate to the image at left, reveals an undeveloped beach stretching north from north of the inlet on a windy day in 1926 or 1927. Today the Sabal Point condominiums, built in the late 1960s, occupy much of this site. The Robbins House, located south of Palmetto Park Road and what would have been the next neighboring structure on the beach, is so distant it is not visible in this image. (BRHS.)

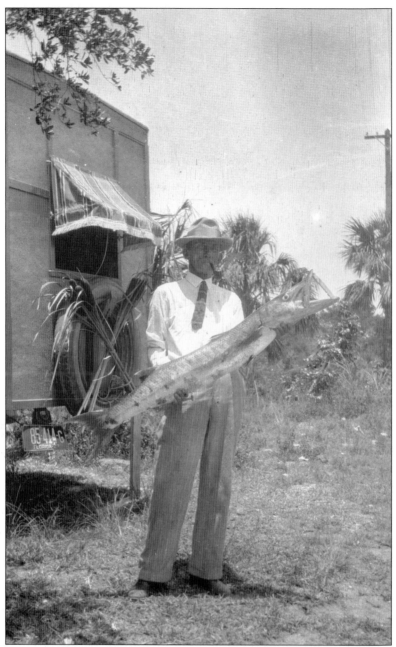

This image from the Harriette and Harley Gates family photograph collection is of a tourist identified only as Arnold holding an impressive barracuda caught off the inlet in Boca Raton. A closer look reveals that Arnold seems to be making his home in a travel trailer of the era—the license plate reads "Florida 1927." The town's commission minutes mention Maurice Stokes's request to establish an "automobile camp" for such travelers in Boca in 1926. Florida's "tin can tourists," in contrast to the bluebloods and high society types of "high season," were "regular folks" who trekked with what we would call an RV south seeking warmth and land. Unfortunately they found few accommodations, tons of mosquitoes and annoying sand flies, and incredible heat and humidity. Many of them returned north to spread the bad word. (BRHS.)

A December 1926 issue of the *Delray Beach News* announced that Dayton and Mamie Habercorn were ensconced in their "new steel house" south of Camino Real and east of Federal Highway, in what is today Royal Palm Yacht and Country Club. This photograph reveals only a portion of the stuccoed house, which appears to be very box-like but with a beautiful arched door. From left to right are Dayton Habercorn, daughter Erma Habercorn, Alva Hollenbeck, and Grant Hollenbeck. (BRHS.)

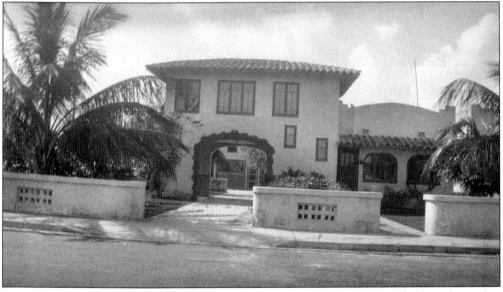

Harley Gates supposedly built the original portion of this Mediterranean-style house located at 136 Boca Raton Road. In 1927, Jack Cramer, the building contractor for Town Hall, purchased the house and added the two-story addition on the east side. The pass-through was to accommodate the driveway, which led to a garage at the back of the property. In later years, the arched opening was enclosed, but the house still stands. (BRHS.)

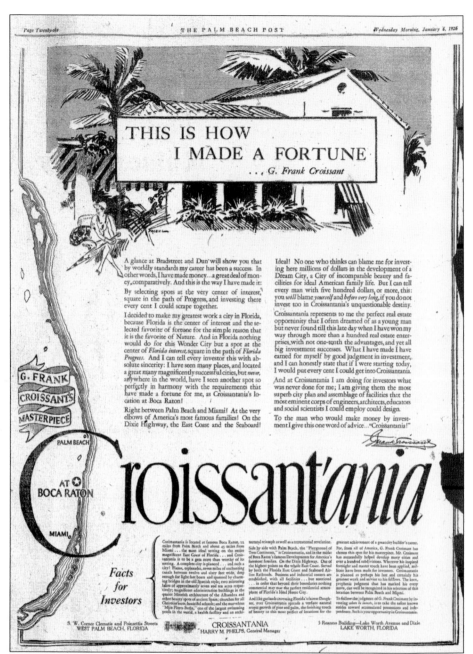

THIS IS HOW I MADE A FORTUNE

...G. Frank Croissant

A glance at Bradstreet and Dun will show you that by worldly standards my career has been a success. In other words, I have made money...a great deal of money, comparatively. And this is the way I have made it:

By selecting spots at the very center of interest, square in the path of Progress, and investing there every cent I could scrape together.

I decided to make my greatest work a city in Florida, because Florida is the center of interest and the selected favorite of fortune for the simple reason that it is the favorite of Nature. And in Florida nothing would do for this Wonder City but a spot at the center of *Florida interest*, square in the path of *Florida Progress*. And I can tell every investor this with absolute sincerity: I have seen many places, and located a great many magnificently successful cities, but *never*, anywhere in the world, have I seen another spot so perfectly in harmony with the requirements that have made a fortune for me, as Croissantania's location at Boca Raton!

Right between Palm Beach and Miami! At the very elbows of America's most famous families! On the Dixie Highway, the East Coast and the Seaboard!

Ideal! No one who thinks can blame me for investing here millions of dollars in the development of a Dream City, a City of incomparable beauty and facilities for ideal American family life. But I can tell every man with five hundred dollars, or more, this: you *will* blame *yourself and before very long*, if you do not invest too in Croissantania's unquestionable destiny.

Croissantania represents to me the perfect real estate opportunity that I often dreamed of as a young man but never found till this late day when I have won my way through more than a hundred real estate enterprises, with not one-tenth the advantages, and yet all big investment successes. What I have made I have earned for myself by good judgment in investment, and I can honestly state that if I were starting today, I would put every cent I could get into Croissantania.

And at Croissantania I am doing for investors what was never done for me; I am giving them the most superb city plan and assemblage of facilities that the most eminent corps of engineers, architects, educators and social scientists I could employ could design.

To the man who would make money by investment I give this one word of advice..."Croissantania!"

G. Frank Croissant

G. FRANK CROISSANT'S MASTERPIECE

PALM BEACH
AT BOCA RATON
MIAMI

Croissant'ania

Facts for Investors

Croissantania is located at famous Boca Raton, 22 miles from Palm Beach and about 45 miles from Miami...the most ideal setting on the entire magnificent East Coast of Florida... and Croissantania is to be a gem more than worthy of its setting. A complete city is planned... and such a city! Plazas, esplanades, seven miles of enchanting canals between twelve and sixty feet wide, deep enough for light feet boats and spanned by charming bridges in the old Spanish style; two mirroring lakes of approximately seven and ten acres respectively; magnificent administration buildings in the quaint Moorish architecture of the Alhambra and other beauty spots of ancient Spain; churches for all Christian sects; beautiful schools; and the marvelous "Mizo Flora Bolta," one of the largest swimming pools in the world; a health facility and an architectural triumph as well as a recreational revelation.

Side by side with Palm Beach, the "Playground of Two Continents," is Croissantania, and in the midst of Boca Raton's famous Development for America's foremost families. On the Dixie Highway. One of the highest points on the whole East Coast. Served by both the Florida East Coast and Seaboard Air-line Railroads. Business and industrial centers are established, with all facilities... but sentiment... in order that beyond their boundaries nothing commercial may mar the perfect residential atmosphere of Florida's ideal Home City.

And like garlands crowning Florida's famous Doughter, over Croissantania spreads a verdant natural tropic growth of pine and palm, the finishing touch of beauty to this most perfect of locations for the greatest achievement of a great city builder's career.

For, from all of America, G. Frank Croissant has chosen this spot for his masterpiece. Mr. Croissant has successfully helped develop many cities and over a hundred subdivisions. Wherever his inspired foresight and master touch have been applied, millions have been made for investors. Croissantania is planned as perhaps his last and certainly his greatest work and service to his fellows. The keen, prophetic judgment that has marked his every move, can well be recognized in his selection of this location between Palm Beach and Miami.

To follow the judgment of G. Frank Croissant by investing where *he* invests, is to take the safest known strides toward accumulated possessions and independence. Such is your opportunity in Croissantania.

S. W. Corner Clematis and Poinsettia Streets
WEST PALM BEACH, FLORIDA

CROISSANTANIA
HARRY M. PHELPS, General Manager

5 Reunno Building—Lake Worth Avenue and Dixie
LAKE WORTH, FLORIDA

Publicity generated by the Mizner Development Corporation's ventures at Boca Raton also drew other investors ready to get a piece of the action. G. Frank Croissant was a Chicago developer, the self-appointed "America's greatest salesman," who had successfully established and promoted Croissant Park, a new subdivision in southwestern Fort Lauderdale. His Croissantania in Boca Raton was located west of Dixie Highway and north of the Mizner Development plats. Lots would be at prices "available to working men who could aid in the up building of the entire community." Frank declared "I have made money . . . a great deal of money. . . . And this is the way I have made it: by selecting spots at the very center of interest, square in the path of Progress." No buildings of the Croissantania development were ever completed. (BRHS.)

ANNOUNCING——————

Boca Raton Heights

Owned and Developed by Boca Raton Heights Corporation

Sale Starts

Monday, November 16th

Location is the Main Factor in Any Real Estate Purchase

Improvements

Five Foot
Sidewalks
Curb and Gutter
Streets
Paved
From
Curb
to
Curb
Lights
and
Water

Restricted
to
Conform
with
the
Zoning
Ordinance
of
Boca Raton

Terms of Sale 20% Down, 10% Quarterly, 6% Interest

Contracts Transferable

Reservations May Be Made at the Office of

C. E. Moulton

Exclusive Agents

West Palm Beach 509 Citizens Bank Bldg. Tel. 1552

Boca Raton Office

J. C. MITCHELL, Inc.

Another planned Boca Raton development that never saw fruition was Boca Raton Heights, a subdivision just south of Palmetto Park Road and just west of the Dixie Highway. New Boca resident J. C. Mitchell, longtime realtor and future mayor, was the president of the endeavor. The map on this *Palm Beach Post* advertisement reveals the location of the intended development across from today's city hall complex. Boca Raton Heights was to feature paved streets, lights, and water with "five foot sidewalks." The subdivision remained largely vacant until World War II, when a public housing project was constructed in this area to serve the civilian personnel employed at the Boca Raton Army Airfield and their families. The latter was later renovated as the Garden Apartments. (BRHS.)

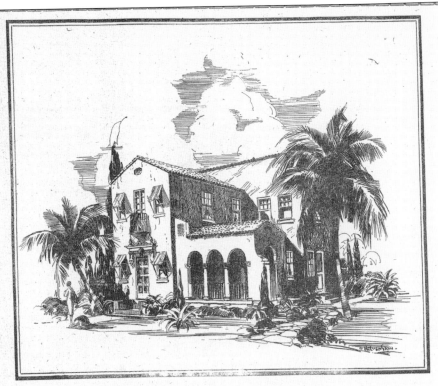

Such Beautiful Homes as this at
VILLA RICA

A DEVELOPMENT is as beautiful as its homes — and as valuable as it is beautiful. Nothing so enhances the value of a community as the erection of beautiful homes, homes on a par with one another, homes in which the architectural treatment is harmonious throughout.

This particular house, now in the course of construction, is but one of the hundreds which will be built, yet it is typical of all that will add their attraction to this development.

In restricting dwellings to only such high class buildings, the developers fully realize that a community of utmost beauty will result and that the natural beauty and charm of Villa Rica will be added to — never depreciated.

To investors this means a great deal, for the construction of such homes as that pictured above cannot help but mean increased valuation and necessarily greater profits.

Geo. W. Harvey Realty Company

DEVELOPERS OF VILLA RICA

| Miami | West Palm Beach |
| 339-341 N. E. First Ave. | 517 Datura St. Phone 1623 |

Washington New York City Pittsburgh
Boston Philadelphia Lake Worth Delray Fort Lauderdale
Miami Beach Office 1661 Michigan Ave.

The biggest competition for Addison Mizner's development was Villa Rica, a 1,400-acre city planned for the northern limits of Boca Raton. Villa Rica was the brainchild of George W. Harvey of Boston, who emphasized Villa Rica's location "entirely within the boundaries of Boca Raton" because nearby developments like Del Raton Park, located in Delray Beach to the north, were clearly marketed to take advantage of the Boca Raton connection. Villa Rica comprised the streets east of Dixie Highway between today's Spanish River Boulevard and Yamato Road. Although the development went bust, Villa Rica enjoyed a revival in the 1960s. (BRHS.)

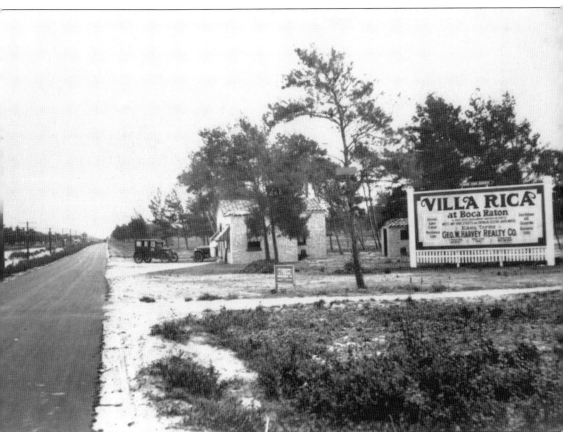

This small Mediterranean-style house located on Dixie Highway served as the sales office for the Villa Rica development. The sign advertised "ocean, lake, and canal residential lots" and "Dixie Highway and Ocean Avenue business lots." Developer George Harvey also commissioned Delray architect Sam Ogren to design a series of Spanish-style buildings to rival Mizner's to the south. The three-story Villa Rica Inn was planned for a site near Spanish River Boulevard overlooking "a pretty little lake." A Florida East Coast Railway passenger station was protested against in the strongest terms by Mizner as potential competition for his planned Addison Station. He also protested Ogren's plan for a two-story Boca Raton post office, which would have been built a couple of miles from Boca's downtown. (BRHS.)

Many of the planned new developments for Boca Raton relied on the appeal of the local waterways. Most of these, originally dredged earlier in the century, were inadequate for period yachts and other vessels. Extensive dredging and bulkheading was needed to prepare "waterfront" lots. Here the Villa Rica dredge takes on what is now the Intracoastal Waterway somewhere near Spanish River Boulevard. (BRHS.)

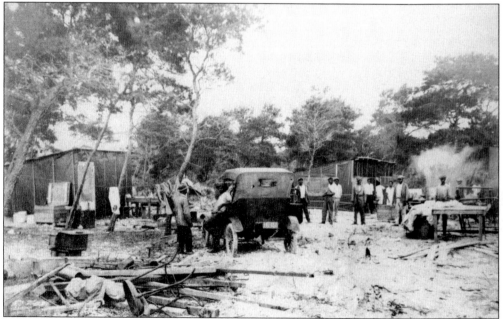

Villa Rica, the Mizner Development Corporation, and other operations required large labor forces to build roads, lay infrastructure, and construct buildings. Many of these laborers were African Americans who came from throughout the eastern United States. While the Mizner Development Corporation built temporary dormitories for its crews, Villa Rica workers lived in shanties on vacant land, as shown above. (BRHS.)

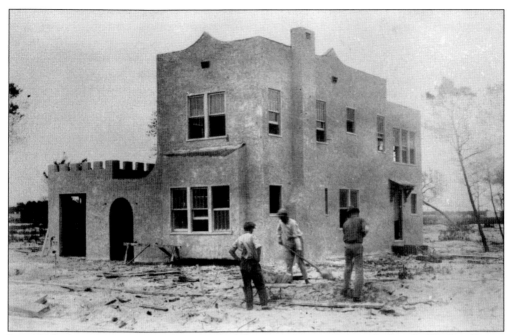

In a 1925 advertisement for the *Fort Lauderdale News*, George Harvey declared, "Work will start immediately on buildings." These homes were to be in the "Spanish or Venetian" style similar to those under construction by Mizner. About a dozen in a somewhat mission style were built between Dixie and Federal Highways. They were soon destroyed by the 1926 hurricane. Here workers clear the land in front of a two-story Villa Rica home with a fanciful crenellated parapet adjacent the front entry. (BRHS.)

The original Villa Rica development stretched from Dixie Highway to the Atlantic Ocean. A 90-foot boulevard named Ocean Avenue was planned similar to Camino Real to the south. The nearest bridge over the Intracoastal at the time would have been at Palmetto Park Road. Harvey had this drawbridge constructed near the present Spanish River Boulevard bridge. It was later relocated, and the spans were not replaced until the late 1960s. (BRHS.)

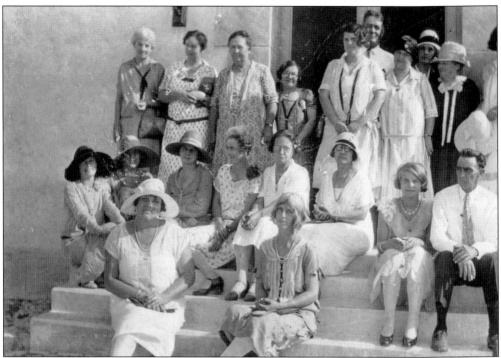

The Boca Raton Woman's Club, formed in the early 1920s, promoted "general philanthropic work, along practical and educational lines." The club grew to 28 members in 1926, a result of the land boom. Above, the club gathers on the steps of the new town hall. From left to right are (first row) Lillian Williams and Harriette Gates; (second row) Eula Raulerson, Ruby Bender, Clementine Brown, Beulah Butler, Mary Alice Lamont, Helen Stokes, Pauline Raulerson, and Mayor John Brown; (third row) unidentified, Peg Young, Florence Purdom, Audrey Purdom, Mamie Riley, Jack Cramer (builder of Town Hall), Mamie Habercorn, Gladys Sherman, and Katie Long. Below, the Woman's Club holds a fund-raising bazaar at the side of Brenk's store, located at the corner of Palmetto Park Road and Northwest First Avenue, around the mid-1920s. (BRHS.)

Addison Mizner's brother, the Reverend Henry W. Mizner, retired to Florida after years of service as the head of St. Stephen's House, an Episcopal mission in St. Louis. Addison actually designed a home for him in the Floresta neighborhood. Henry established Boca Raton's first Episcopal church in what had been a field office on the Dixie Highway at about Southeast Fourth Street in December 1926. He conducted services for about a year, and Addison announced plans for the construction of a great new church to be built in Boca Raton. The land boom ended plans for the new parish, and Henry and his family moved to Paris after foreclosures in the Floresta neighborhood. At right is the modest St. Mary's Chapel exterior, c. 1926. Below, an interior view shows the rustic chapel ready for Easter service in 1927. (BRHS.)

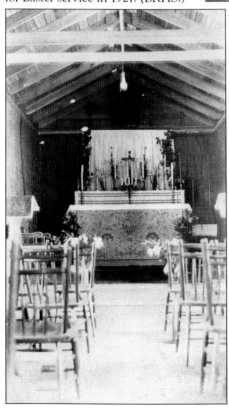

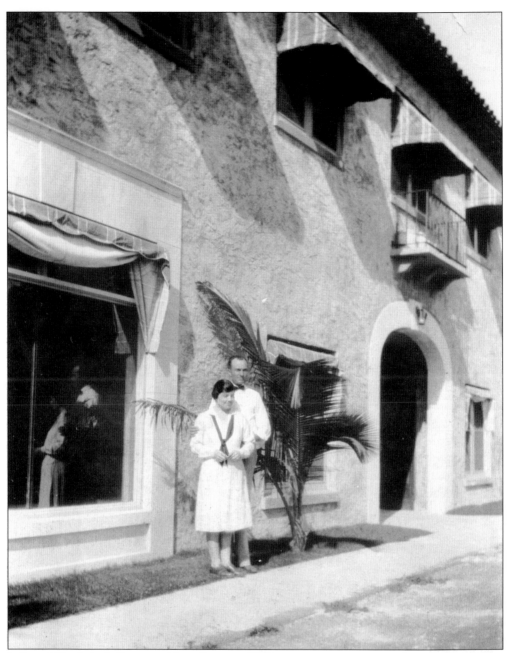

J. C. and Floy Mitchell came to Boca Raton in 1923 to manage property purchased by his father-in-law in the area. Realizing the economic opportunities of the region, he quickly launched into the real estate business himself. He constructed the Mitchell Arcade, a combination retail and apartment building on Dixie Highway just south of Palmetto Park Road in 1925. The Mitchells made their home in one of the apartments there. During the September 1926 hurricane, they were unaware of the need for boarding up windows and other preparations. They had a front-row seat for the category four storm as they watched freight cars blown off the tracks across the street. The roof was torn off, but the arcade was rebuilt. The arcade survived until destroyed by fire in 1988. (BRHS.)

Five

BUILDING A TOWN

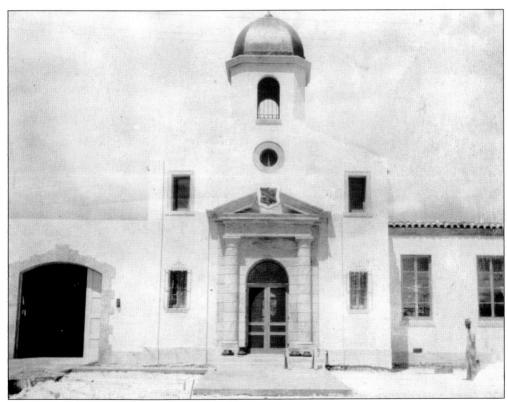

The newly incorporated town of Boca Raton appointed Addison Mizner as town planner. His duties included a design for a city hall. Two versions proved too costly for the town fathers, and although foundations had already been laid, Boca Raton engaged Delray architect William Alsmeyer to complete the final design of the building. Here a worker is visible near the main entrance to the unfinished Town Hall in early 1927. (BRHS.)

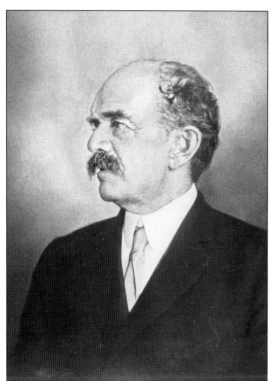

When the town of Boca Ratone was first incorporated in 1924, pioneer George Long was appointed mayor. A Harvard graduate originally from Boston, he had followed his friend Thomas Rickards to the area in the 1890s. Long served as the agent for the Florida East Coast Land Department, as postmaster, and as county commissioner. His devotion to the community was unceasing, and when he died in 1929, his funeral was held in the Council Chambers at Town Hall. (BRHS.)

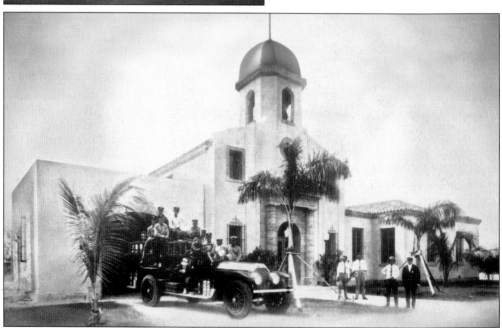

Boca Raton's Town Hall was open for business in April 1927 on the King's Highway (now Federal Highway) just north of Palmetto Park Road. It was for many years one of the town's tallest landmarks. Town Hall was also home to the fire department, shown gathered at left. In the 1980s, the Boca Raton Historical Society restored the structure as their headquarters and historical museum. It is today on the National Register of Historic Places. (BRHS.)

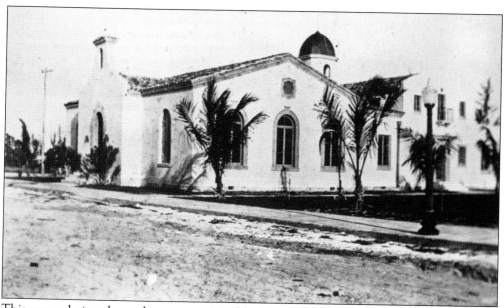

This unusual view shows the new municipal building from the northwest angle shortly after completion. Note the new landscaping, sidewalks, and streetlights. This photograph may have been taken in May 1927, when the streets surrounding the building were widened. In the 1960s, the city constructed a new city hall two blocks west on Palmetto Park Road. Town Hall continued to house various municipal agencies until the 1980s. (BRHS.)

Town Hall featured a beautiful Council Chamber on the first floor, probably the largest available meeting venue in town. Many public events were held in its downstairs rooms, decorated with tiles, woodwork, and ironwork made by Mizner Industries. In this picture, the 1928 graduating class of the Boca Raton School pose after the ceremony in front of Town Hall. From left to right are (first row) usher Betty Leigon; (second row) Oveida Brown, Pauline Raulerson, and Dixie Sellers. (BRHS.)

In May 1925, Boca Raton once again incorporated, this time as the town of Boca Raton (with no "e"). Elections were held, and the town's first elected mayor was John Brown. Mayor Brown oversaw the building of Town Hall and establishment of the fire and police departments and many other pivotal governmental services. This view shows Mayor Brown with his wife, schoolteacher Clementine, at left, and daughter Betty in their laps, c. 1928. (BRHS.)

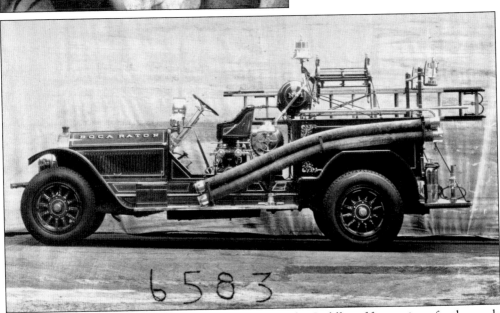

In 1926, Boca Raton purchased an American LaFrance, the Cadillac of fire engines, for the newly incorporated community at a cost of $12,500. The end of the Florida land boom and the resulting Depression meant that the town continued paying for the expensive equipment for many years. The engine made her home in the fire bay of the then-new Town Hall. "Old Betsy" was restored in the 1990s and today is listed on the National Register of Historic Places. (BRHS.)

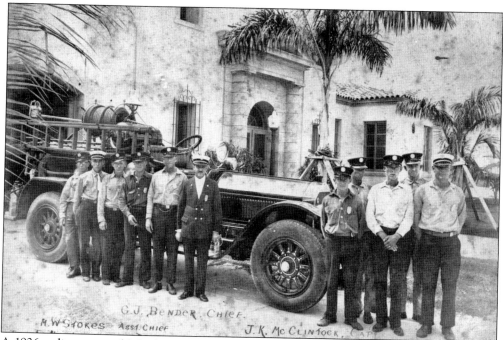

A 1926 ordinance established a volunteer fire department with a paid "chief of fire," assistant chief, and driver. The department poses in front of the fire bay at Town Hall in August 1927. Pictured from left to right are Stroud Eldredge; M. W. Stokes, assistant chief; O. Ozier; John LaMont, driver; Harry Purdom, assistant driver; Guy Bender, fire chief; O. Arnold; Sam Jerkins; F. M. Thomason; Kline Platt; and J. K. McClintock, captain. (BRHS.)

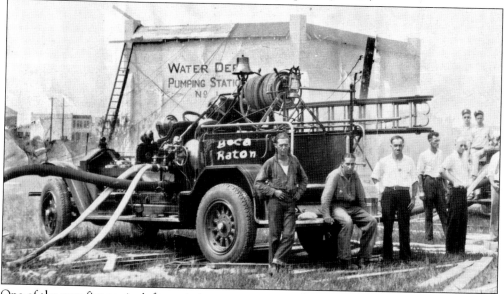

One of the new fire engine's first missions was service to the city of Hollywood, Florida, located about 25 miles to the south, in the aftermath of the 1926 hurricane. Old Betsy and two other tankers helped drain storm waters and provided water for Hollywood's four hotels, which served as evacuation shelters. This photograph by C. F. Higby, a professional Hollywood photographer, was taken adjacent the city of Hollywood's water tanks. (BRHS.)

One of the new town's first orders of business was to provide police protection for the rapidly increasing local population. In September 1925, Charles J. Raulerson was appointed as first town marshall with a salary of $175 per month. In this photograph, Raulerson stands at left next to Deputy Leo Godwin. They stand in front of the department's Ford; Boca Raton's wooden Florida East Coast Railway freight station is in the background. (BRHS.)

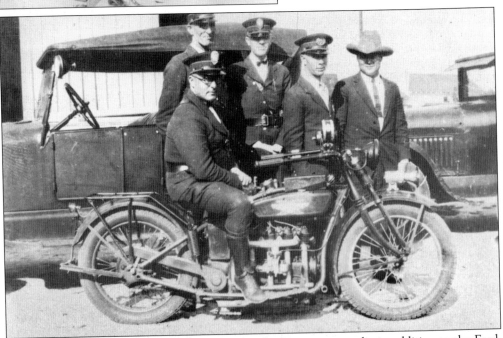

By 1926, the police department had five members and two motorcycles in addition to the Ford. Marshall Ira Blackman sits on the motorcycle. Behind him, from left to right, are Dan Kaniff, Rufus White, Charlie Raulerson, and Leo Godwin. As the land boom ended, the town could no longer afford to keep such a large force. By 1929, Boca Raton temporarily lost its police department. (BRHS.)

106

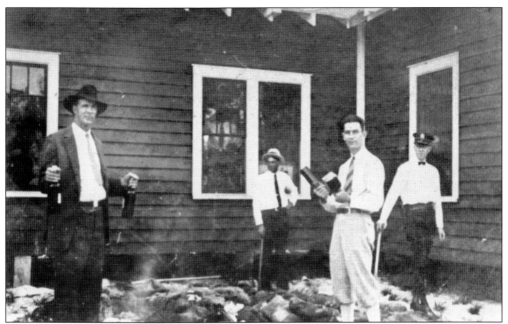

Despite the Prohibition Act in force during the 1920s, a great deal of liquor made its way to the shores of southeastern Florida via the Bahamas courtesy a very active bootlegging trade. In September 1926, someone spotted a boat unloading cargo on Boca's deserted beaches. The next day, the police found a stash of liquor bottles under a wooden building on South Dixie Highway at about Southeast Fourth Street. Above, city officials check out the bootlegger's booty. From left to right are B. B. Raulerson, unidentified, Mayor John Brown, and Charlie Raulerson. Below, a view looking north on Dixie Highway reveals the building in question at right in 1925. Ironically the building would serve as a surveying field office, temporary town hall, and later St. Mary's Episcopal Chapel. (BRHS.)

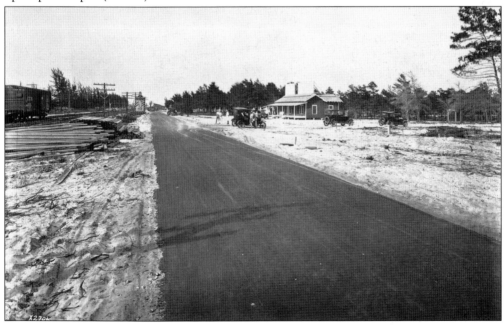

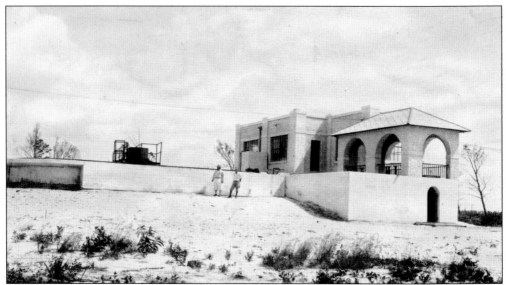

In 1927, Clarence Geist purchased the assets of the Mizner Development Corporation and proceeded to enlarge and remodel the Cloister Inn as the new Boca Raton Club. Geist owned a number of utilities, which supplied water to the Philadelphia area; he was interested in ensuring the water supply for the guests at his new hotel. He made a low-interest loan of $55,000 to the town for construction of a water plant. The handsome plant, built in a Mediterranean style on the site of the present Boca Raton City Hall, was the most modern in the state at the time. It served the community until the 1960s. Above is a view of the plant in April 1929, shortly after operations began. Below, an early-1930s view shows the Boca Raton water tower and tropical landscaping of the facility. (BRHS.)

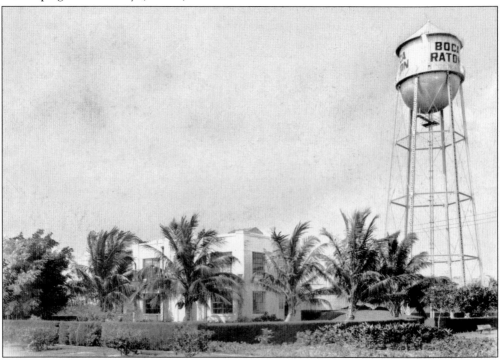

Six

WE'RE STILL HERE

By 1926, the Florida land boom had slowed, hurried by rail embargoes on building supplies, bad publicity from Northern newspapers, and disgruntled summertime visitors. Two killer hurricanes, one in September 1926, the other in September 1928, brought the Depression to South Florida ahead of the rest of the nation. Boca Raton's committed residents persevered, however. This view shows the newly landscaped but not quite paved Camino Real looking east from Federal Highway, c. 1929. (BRHS.)

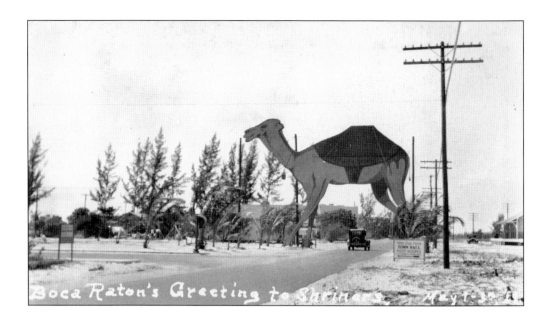

Boca Raton's Greeting to Shriners. May 1928.

In the spring of 1928, the Shriners held their national convention in the up-and-coming city of Miami. In a desperate attempt to gain publicity for Boca Raton, now bereft of the Mizner Development marketing machine, the town council agreed to pay $1,000 to erect a giant camel, symbol of the Shriners, across Dixie Highway behind Town Hall. The camel was marked "Welcome Nobles," and a sign urged passers-by to "visit our new Town Hall" and the restrooms there. Any Shriners coming via car would have driven under this very creature. A few months later, the camel became an elk, in time for the national Elks convention, also held in Miami. Above and below are two views of the camel, which reveal the quiet scene along Dixie Highway in "downtown Boca" in 1928. The photograph above shows Dixie Highway looking south from Boca Raton Road; the photograph below is the view looking north from just north of Palmetto Park Road. (BRHS.)

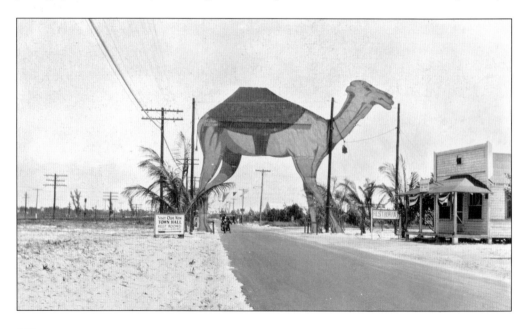

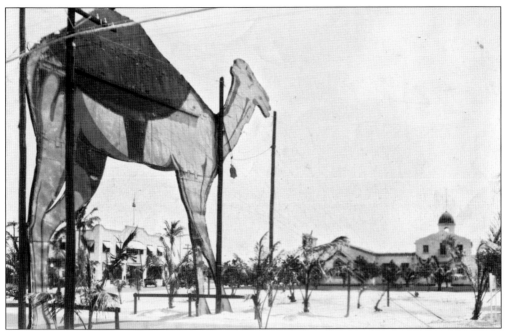

This close-up view of the Shriner camel reveals a rare look at the western facade (back side) of Town Hall at right. That white stuff in the picture is not snow but Boca's very own sugar sand. At left, visible between the camel's legs, is the new Brenk Building, later known as the Haggerty Building. This structure was home to retail businesses and, in later years, the post office and was the first home of the modern chamber of commerce. It was demolished in 2002. (BRHS.)

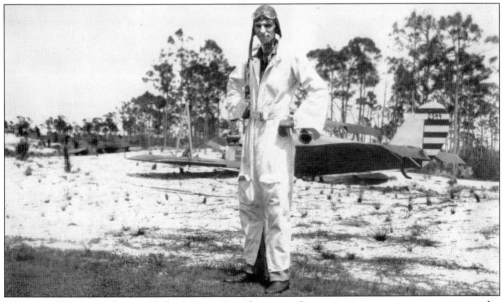

Clarence Geist, purchaser of the Mizner Development Corporation interests, commissioned a pilot to shoot aerial photography of his holdings in 1929. The pilot crashed but suffered minor plane damage. This image is thought to be a picture of the pilot, identified as Jack Walden, on September 17, 1929. A few years later, Geist began a campaign to bring a Works Progress Administration–funded airstrip to Boca Raton. (BRHS.)

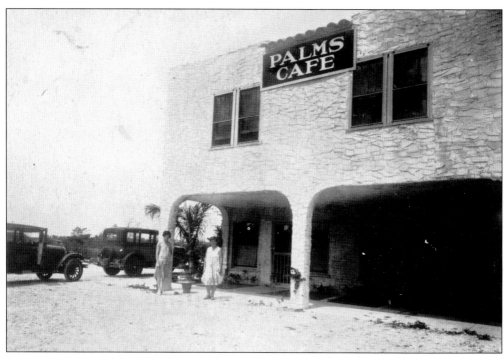

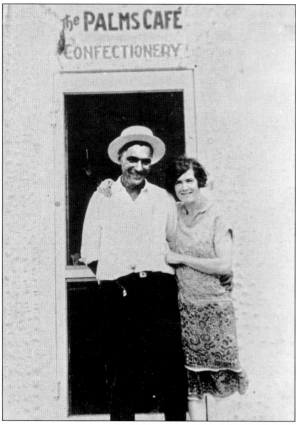

Lola and Louis Zimmerman came with their daughter Lucille to the boomtown of Boca Raton from Philadelphia in 1925. The opened a restaurant on Palmetto Park Road east of Federal Highway and called it the Palms Café. Despite the bust of the land boom, in 1928 they moved to new quarters in a building west of the Florida East Coast Railway tracks and just north of the old wooden freight station, on a spot on what is now Northwest Second Street. Later the Zimmermans erected a building on Federal Highway, calling it Zim's Bar. The old Palms Café served as housing for the families of men serving at the Boca Raton Army Airfield during the war. It was demolished in 1985. Above, Lola (left) and an unidentified friend stand outside the café in 1929. At left, Louis and Lola are pictured outside the entrance to the first Palms. (BRHS.)

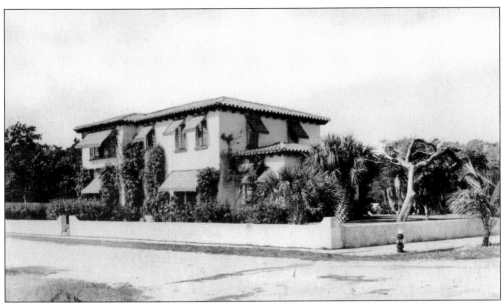

Thomas Giles, an engineer who had worked on the Mizner Development Corporation projects, had this Mediterranean-style house constructed in 1928 on Palmetto Park Road east of the bridge. He acquired the plans for the house from a now-unidentified West Palm Beach architect. The house allegedly incorporated salvage from the MDC projects. The home later became the Por La Mar Apartments, a commercial establishment, and La Vieille Maison restaurant. It still stands at 770 East Palmetto Park Road. (BRHS.)

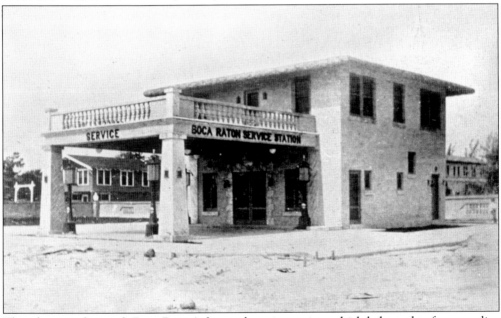

This photograph reveals Boca Raton's first real service station, which belonged to former police chief Ira Blackman and was located at the southwest corner of Palmetto Park Road and Dixie Highway. It was constructed in 1928 and featured apartments above and a restaurant below. In this photograph, the paving around the building appears to be unfinished. At left is Hattie Long Deyo's home. The back of the Mitchell Arcade is visible at far right. (BRHS.)

A wooden freight depot, which stood along the Florida East Coast tracks just north of Palmetto Park Road, served as the town's only train station in 1928. Clarence Geist allegedly purchased stock in the FEC in order to ensure the construction of a depot worthy of his hotel guests. Architect Chester G. Henninger completed the design for the Spanish-style station, and construction began late in 1929. Above, laborers begin work on the new station in November 1929. Dixie Highway was actually rerouted to accommodate the station—the road still curves eastward at that point. Note the Administration Building in background at left. Below, construction moves along quickly on the hollow clay tile building in this view looking north and east from the tracks in December 1929. Note the lack of development along Dixie and Federal Highways, shown in the distance. (BRHS.)

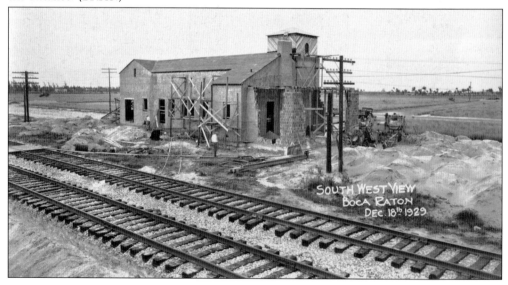

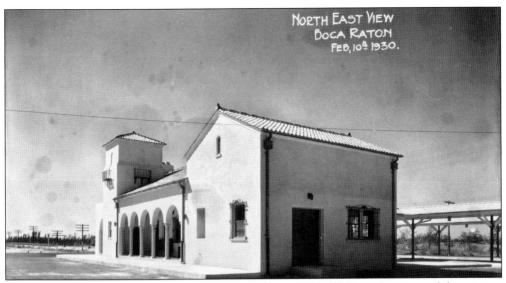

Boca Raton's new passenger station, typical of the Florida East Coast railway period depots, was completed in the still-popular Mediterranean style early in 1930. In the 1960s, passenger service ceased on the FEC and the little station sat derelict for many years. In the 1980s, the Boca Raton Historical Society acquired the property and restored it to its former beauty. Today it is on the National Register of Historic Places and serves as a community center and the home of the Boca Express train museum. Above is the station looking south and west from the main facade in February 1930. Below, the handsome tiled interior of the white waiting room is still intact today. Until the end of segregation, most train stations in the South featured separate facilities for white and African American customers. (BRHS.)

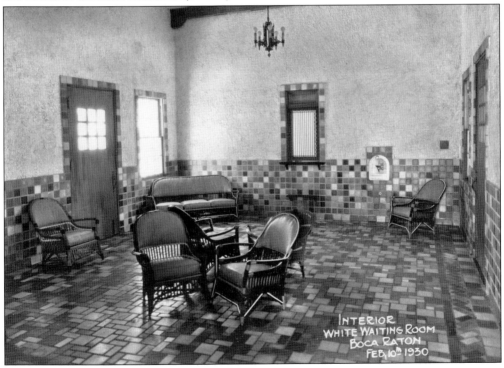

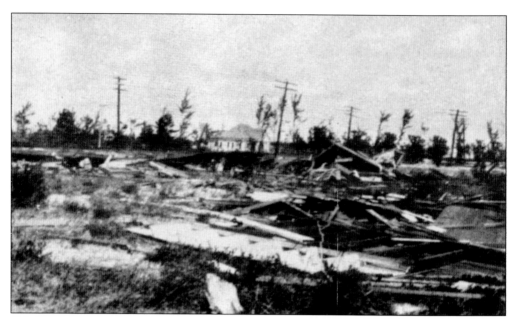

Boca Raton was the victim of two major hurricanes in the late 1920s. The "Miami Hurricane" of September 18, 1926, brought hurricane-force winds from the upper Keys to West Palm Beach. Boca's high beach bluff largely protected the small town from the terrible storm surge. In 1928, Boca suffered the effects of the southern tip of the "Palm Beach Hurricane." The latter was particularly deadly, causing thousands of deaths in the Lake Okeechobee area. Residents considered themselves very fortunate for having survived with relatively little damage and no loss of life considering the havoc they observed to the south and north after both of these storms. Yet the effect was long felt, as the hurricanes brought the land boom to a bitter and final end. Above, Singing Pines sits amidst rubble after the 1928 storm. Below, a Boca Raton promotional bus is another symbolic victim. (BRHS.)

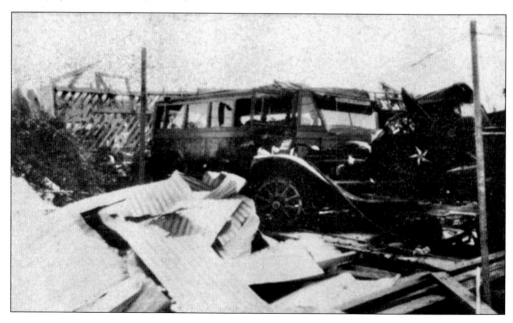

Seven

THE BOCA RATON CLUB

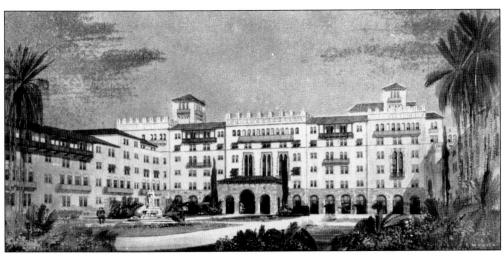

In 1927, the Mizner Development Corporation properties were acquired by one of the original investors, Clarence Geist. Geist commissioned the New York architectural firm of Schultze and Weaver to create an addition to the Cloister Inn. This rendering features the south facade and main entrance to the Boca Raton Club, *c.* 1928. The hotel welcomed guests at Christmas 1929 and was formally opened by the arrival of Geist in January 1930. (BRHS.)

Clarence Geist planned to establish a private winter club in Boca Raton. He formed the Spanish River Land Company and invested tremendous amounts of capital on the renovation of the hotel. Geist was also responsible for the construction of a new train station, water plant, and other important amenities for the little town, still stinging from the end of the boom. This photograph shows Clarence and Florence Geist upon their arrival sometime in the early 1930s. (BRHS.)

This fascinating view taken from atop the Boca Raton Club c. 1929 reveals the original Cloister Inn at left. Mizner's beautiful palace was fully incorporated into the new design and served as inspiration for the new "wings," which dwarfed the original hotel. At far left is Lake Boca Raton and the East Coast Canal. No bridge yet existed at Camino Real. (BRHS.)

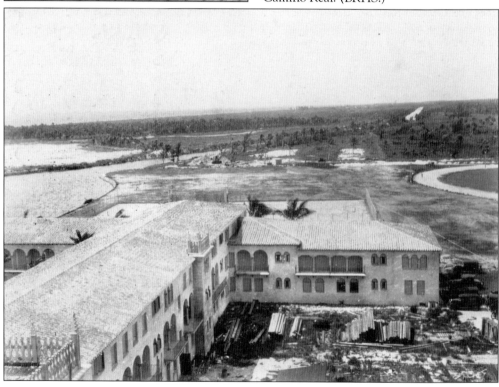

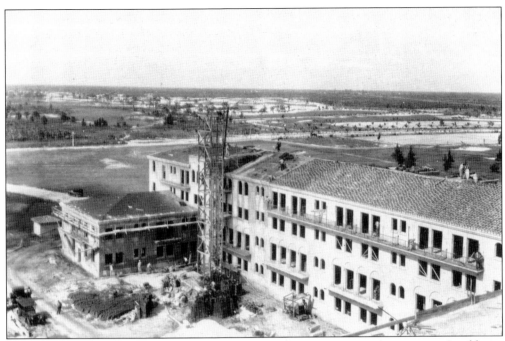

Plans for the new hotel were completed by March 1928, and construction began apace. In addition to the renovation of the building, Camino Real was expanded and landscaped and the golf courses improved. Above, this view looks south and west from atop what is now the main entrance to the hotel. The southwest wing of the current Boca Raton Resort and Club is visible, and palm trees line Camino Real in the distance. Below, golf enthusiast Geist had the Cloister Inn golf courses redesigned by Toomey and Flynn. An 18-hole course and 9-hole practice course were to be joined by another full course, according to brochures of the time. (BRHS.)

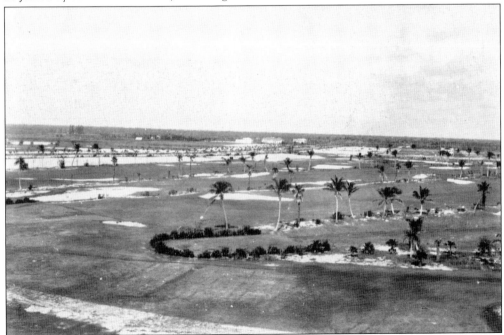

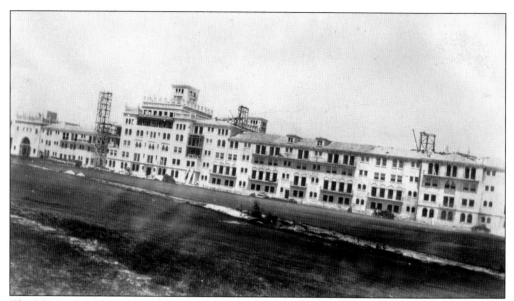

The 300-room addition to the Cloister Inn featured a six-story building surrounding a large square entrance courtyard. Schultze and Weaver, well known for their work on the Breakers in Palm Beach and the Biltmore in Coral Gables, were especially respectful of Mizner's original design. The towers and arched portals of the Cloister Inn were mimicked in the newer parts of the hotel. Above, the expansive western facade of the hotel is now obscured by plantings and additions like the spa. Below is an interesting view of laborers beside the west wing from inside the main courtyard. The main entrance and lobby would be at the right, out of the picture. (BRHS.)

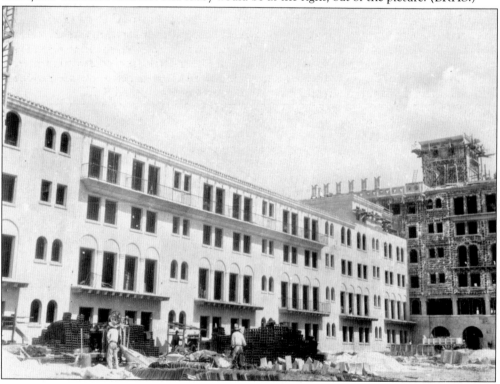

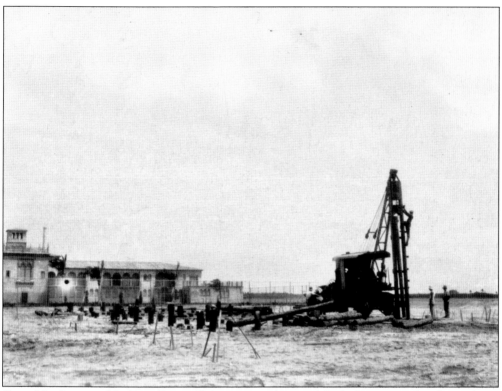

One of the features of the Boca Raton Club was an outdoor pool, built above ground at the southeast corner of the property where the Great Hall of the Boca Raton Resort and Club stands today. The pool featured beautiful arcades, tile work, wood-beamed ceilings, and wrought-iron grilles, probably products of Mizner Industries. The south end of the pool featured a curved center. Access was by a series of stairs on the west or east side. Above, the pilings are driven for pool construction in 1929. The southern wing of the original Cloister Inn is in the background. Below, Minnie Parkhurst (left) and sister Harriette Gates (right) visit the completed pool c. 1930. (BRHS.)

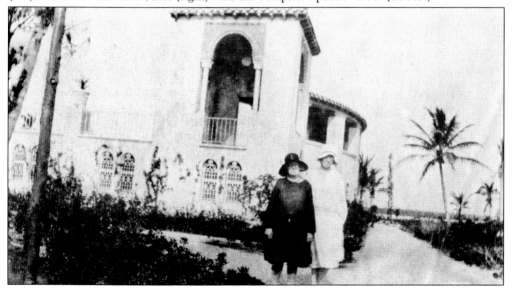

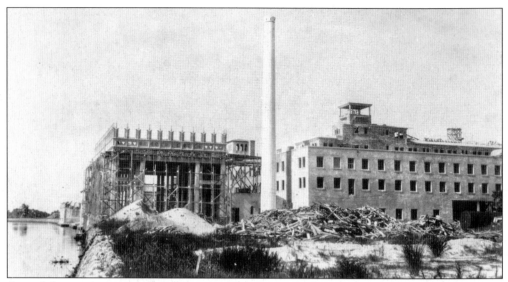

One of the important features of the new Boca Raton Club was a palatial new dining room. It originally sat directly on the lakefront, at the northern end of the hotel. Above, the construction of the Cathedral Dining Room shows the western edge of Lake Boca Raton at left and the northern facade of the main portion of the hotel at right. A service incinerator stack sits at center. Below is an exterior view of the dining room when it was first constructed. A "dance patio" overlooked the lake. In the mid-1930s, Geist commissioned architect Marion Syms Wyeth to remodel this area with an open arcade. Notice the Mizner Industries candelabras around the patio. (BRHS.)

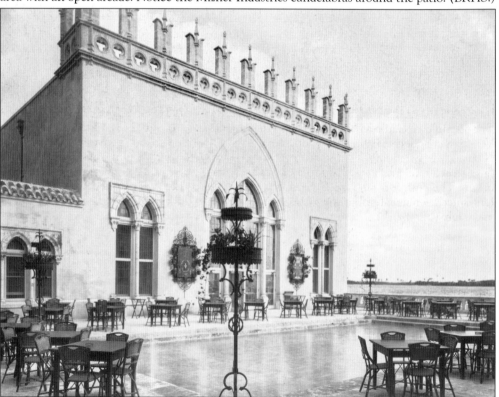

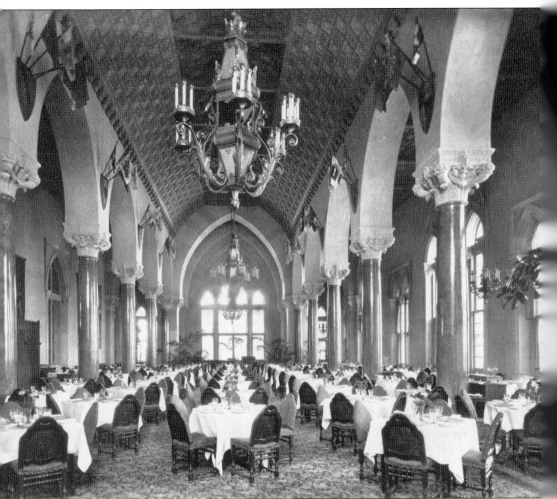

The magnificent Cathedral Dining Room featured gold-leafed columns and coffered ceilings. Giant Venetian chandeliers lighted the room. An elegant tripartite window graced the northern end. Flags and banners hung near the ceiling in baronial fashion. A raised aisle on the right allowed diners a beautiful lake view. Today the Cathedral Dining Room is little changed from its original design. The northern window has been blocked by later construction, and the furnishings have long since been updated, but the room is still the premier dining spot at the Boca Raton Resort and Club. (BRHS.)

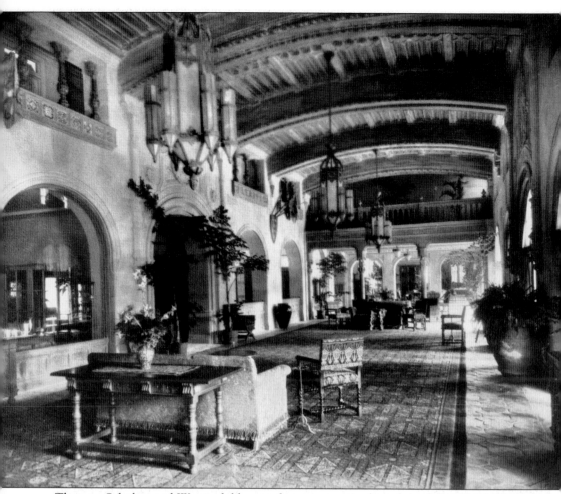

The new Schultze and Weaver lobby was far more ornate than that of the Cloister Inn. Two stories, it stretched the length of the northern wing of the structure. It featured exposed wooden beams, decorative painted coffers on the east and west sides, and Florida keystone columns with figurative capitals. E. A. Belmont of Philadelphia served as the interior decorator, and Ohan S. Berberyan, a Palm Beach art dealer, assisted in acquiring furnishings for the club, according to newspaper reports of the time. In an article written for the Southam chain of newspapers in the late 1920s, C. O. Smith reported, "To picture the main lobby, the various lounges, the dining room, its inner and outer dancing patios, its courts with their fountains, palms, and shrubs, I would be compelled to employ adjectives that would seem sheer exaggeration. Yet there would be no exaggeration. . . . But put simply, this is regarded as the loveliest structure, in construction and equipment, utilized for such purposes, ever erected in the world." (BRHS.)

The public rooms of Mizner's Cloister Inn were remodeled for the club. At right, the former dining room, recognizable by its vaulted ceiling, became the new club's main lounge area. An ornate new fireplace was added at the north end of the room. In the 1950s, this room was divided horizontally. The second floor is currently the Mizner Room. The lower section forms a hall and shops east of the main lobby. (BRHS.)

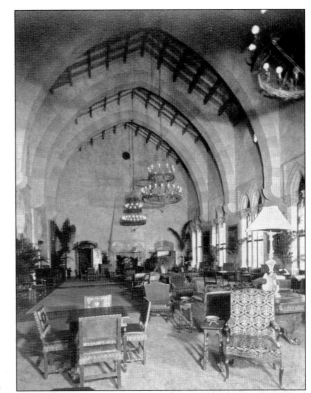

Mizner's "great hall" or ballroom also became a lounge. It is still clearly recognizable in this photograph from the early 1930s. The original fireplace stands at center right. At the center of the photograph sits a large movie screen. Films were one of the common entertainments offered to the guests. There were no nearby movie theaters or other venues when the new hotel opened its doors. (BRHS.)

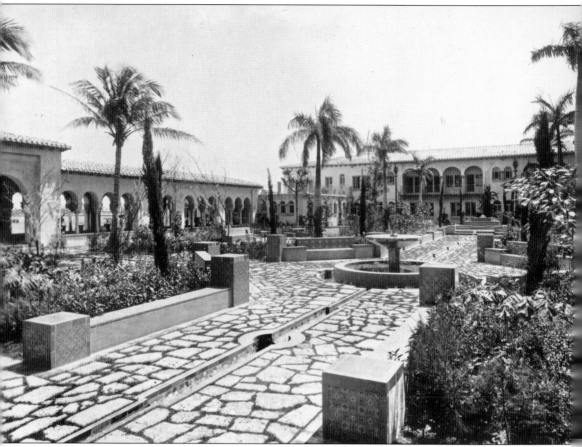

The courtyard of the original Cloister Inn also underwent a dramatic transformation in 1929. A new garden in the "chahar bagh" style featured Persian-inspired water channels, tiled walkways, and fountains. These were supplemented by beautiful plantings and large jardinieres and other planters provided by Mizner Industries. The new garden seemed ideally suited to its setting in the old Cloister Inn. At left can be seen the original cloister. In the background at right sits the southeastern wing of the Cloister Inn, demolished in the 1960s. The channels have since been filled in because of safety concerns, but the Cloister Garden can still be enjoyed by hotel guests. (BRHS.)

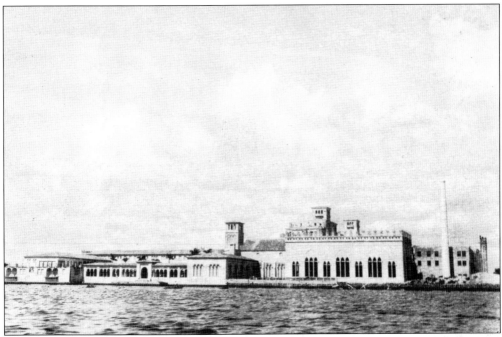

Despite the large sums of money expended on the new hotel, Geist's investment could not revive the land boom as hoped. The new Boca Raton Club, however, became in many ways the savior of the young town, which reverted largely back to its agricultural roots in the 1930s. The Boca Raton Club, today the Boca Raton Resort and Club, became an important source of income for many residents and a vital factor in the local economy in the years to come. Above, the completed Boca Raton Club is viewed from Lake Boca Raton, c. 1929. Below, the entire complex including the pool at left, tennis courts, golf courses in the distance, and Camino Real are shown in an aerial view taken later in the 1930s. (BRHS.)

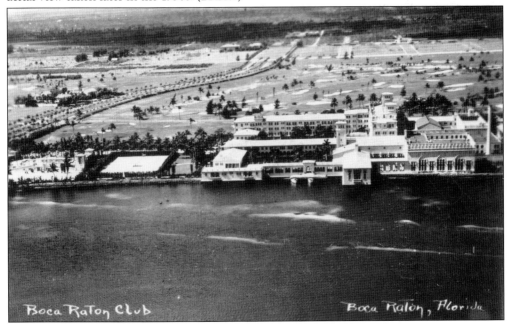

Boca Raton Club Boca Raton, Florida

Across America, People are Discovering Something Wonderful. Their Heritage.

Arcadia Publishing is the leading local history publisher in the United States. With more than 3,000 titles in print and hundreds of new titles released every year, Arcadia has extensive specialized experience chronicling the history of communities and celebrating America's hidden stories, bringing to life the people, places, and events from the past. To discover the history of other communities across the nation, please visit:

www.arcadiapublishing.com

Customized search tools allow you to find regional history books about the town where you grew up, the cities where your friends and family live, the town where your parents met, or even that retirement spot you've been dreaming about.